DORSET'S BLACK GOLD

A HISTORY OF DORSET'S OIL INDUSTRY

ALAN TAYLOR

AMBERLEY

First published 2021

Amberley Publishing
The Hill, Stroud,
Gloucestershire, GL5 4EP

www.amberley-books.com

ISBN: 978 1 3981 0348 1 (print)
ISBN: 978 1 3981 0349 8 (ebook)

British Library Cataloguing in Publication Data.
A catalogue record for this book is available from the British Library.

Typeset in 10pt on 13pt Celeste.
Typesetting by SJmagic DESIGN SERVICES, India.
Printed in the UK.

Contents

1

Dorset Oil in Outline

The aim of this book is to give a history of Dorset's oil industry from early Victorian times to the present day. Viewed by many, residents and visitors alike, as a rural county with an interesting Jurassic coastline of World Heritage status, the fact that Dorset also has an oil industry of note might come as a surprise. Yet, it is the unique geology of the Wessex Basin, portrayed in the coastline from Dorset to East Devon, which gives rise to the formation and trapping of oil deep under the Dorset countryside. This book is for all those people who have an interest in Dorset's history and the Jurassic Coast.

There are many references to oil discoveries in Dorset; these can be found in newspapers, learned journals of scientific societies, books about the geology of the Jurassic Coast and of course the internet. Open access via the internet to databases held by the Oil and Gas Authority (OGA) and contributors has enabled the author to produce a set of unique maps and diagrams to illustrate the historical development of Dorset's oil. This book is an attempt to bring much of this information together into one volume.

The 'Black Gold' in the title of this book refers to a term used, particularly in the twentieth century, to describe crude oil. The 'Black' comes from the colour and the 'Gold' comes from its perceived monetary value. However, the history of Dorset's oil goes back long before this term came into vogue. During the mid-nineteenth century, engineers in Midlothian in Scotland successfully extracted oil from shale by heating it in retorts. At around the same time similar attempts were made to begin a shale oil industry in Dorset. From around the 1830s to the end of the nineteenth century there were many attempts to extract oil and gas from shale mined at Kimmeridge in Dorset. Although these attempts were successful in producing oil and gas, they all failed to be commercially viable. The main reason for this failure was Kimmeridge shale has higher sulphur content than its Scottish counterpart. These sulphur compounds tainted the produced oil and gas with unacceptable odours, which made the products difficult to sell. Surprisingly, the only surviving relic of the English shale oil industry is not to be found in Dorset but at Kilve in Somerset, where a similar industry sprang up for a short time.

It was the geologists of the D'Arcy Oil Exploration Company (later to become BP) who first realised the significance of the oil seeps found along the Dorset coast. This led to onshore exploration drilling in Dorset during the 1930s. However, the relatively shallow

wells drilled at the time failed to find any oil. Exploration drilling in Dorset stopped for the duration of the Second World War. After the war ended, exploration drilling was again taken up by BP, which led to the discovery of Dorset's first commercial oil well in 1959, sited on the clifftop at Kimmeridge. This well is still producing oil today, sixty years later, and can easily be spotted by visitors to the area.

Once onshore exploration in the United Kingdom had got underway, regulations were introduced in 1928 and 1936, which vested all rights to the nation's petroleum resources in the Crown. This meant that companies drilling for oil and gas had to get a licence to do so. Over the years the system evolved, culminating in the Petroleum Act of 1998. This gave rise to licence blocks dividing up the land into areas that could be explored for oil and gas and subsequently produced. Although licences have been issued for exploration covering most of the county, the current licences held by companies are in the south, which gives an indication of the hydrocarbon prospectivity of this part of Dorset.

Onshore exploration drilling in Dorset by large and small oil companies occurred in bursts of activity during the mid-1950s to early 1960s, then again throughout the 1970s and 1980s. However, by the new millennium this activity had slowed to only two onshore exploration wells drilled in the last twenty years. Up to the beginning of 2020, some sixty exploration wells, distributed throughout the county, had been drilled in Dorset. All this exploration activity led to the discovery and subsequent development of the giant

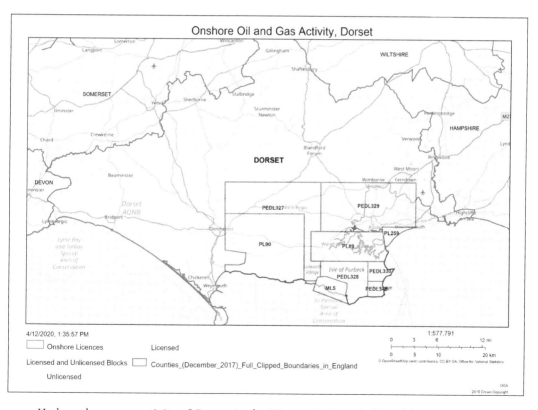

Hydrocarbon prospectivity of Dorset in the Wessex Basin as indicated by the current licence blocks. (Contains information provided by the OGA 2015 Crown Copyright)

oilfield at Wytch Farm and two smaller oilfields at Wareham and Waddock Cross, in addition to the one at Kimmeridge.

By 1990 exploration drilling had given way to the drilling of wells to develop the oil discoveries at the Waddock Cross, Wareham and Wytch Farm oilfields. At the end of 2015, a total of 284 wells had been drilled in Dorset. This total included all sixty exploration wells, ten appraisal wells and 214 development wells. Appraisal wells were drilled to further investigate the newly discovered oil reservoirs at Waddock Cross, Wareham and Wytch Farm. The development wells consisted of oil production wells and wells to inject water as part of a controlled water flood to assist oil recovery from the Wareham and Wytch Farm oilfields. Water injection, in this case, should not be confused with the recently introduced technique of hydraulic fracturing, popularly known as 'fracking'. The technique is used to extract oil and gas from deeply buried impermeable shale reservoirs, which are now categorised as being unconventional hydrocarbon resources. This distinguishes them from the long-established techniques for developing oil-bearing rock reservoirs of permeable sandstone and limestone, which are now categorised as conventional hydrocarbon resources. All Dorset's oilfields and wells mentioned in this book are categorised as conventional and have, therefore, not involved hydraulic fracturing. As if to advertise the traditional nature of Dorset's oil industry, many wells have been fitted with beam pumps,

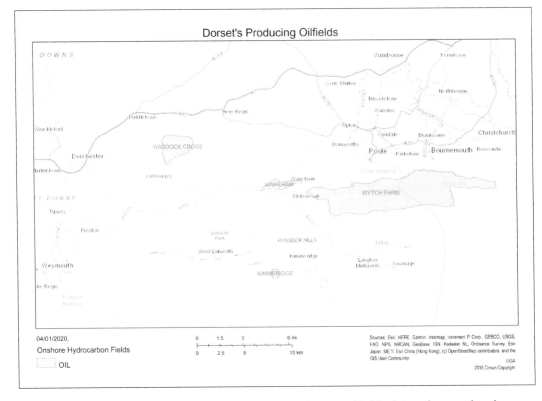

Map showing the location and extent of Dorset's producing oilfields, lying deep under the ground and also deep under Poole Bay in the case of Wytch Farm oilfield. (Contains information provided by the OGA, OGA 2015 Crown Copyright)

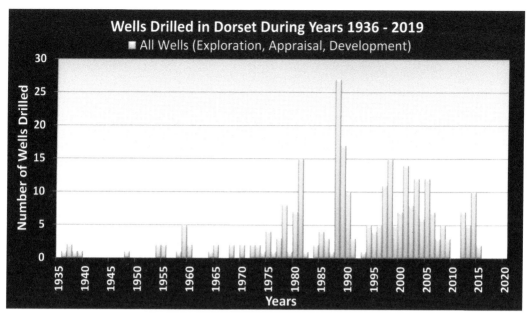

Wells Drilled in Dorset During Years 1936 - 2019

■ All Wells (Exploration, Appraisal, Development)

Number of Wells Drilled

Years

Above: A timeline of wells drilled in Dorset during the years 1936 to 2019. This includes exploration, appraisal and development wells. Development wells are oil producers and water injectors. Up to 1975 the wells were mainly for oil exploration. (Author, contains information provided by the OGA)

Below: Beam pumps, 'nodding donkeys', at Wytch Farm oilfield. Many of the wells in Dorset were fitted with these pumps to help lift oil to the surface. (Roman Hobler, CC-By-SA 2.0)

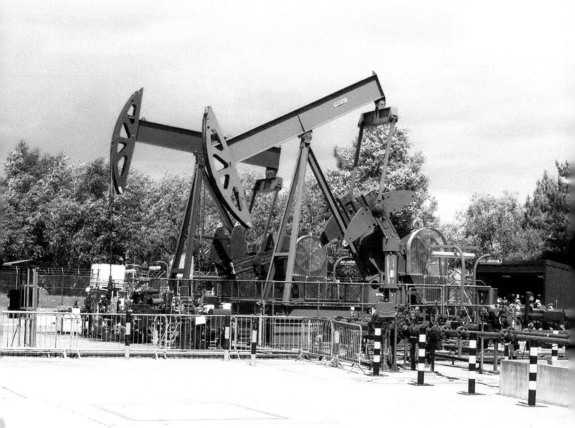

'nodding donkeys', to help lift oil to the surface. Such pumps have been in use around the world for at least 100 years.

By the mid-1990s Dorset's oil industry had become a major onshore oil producer not only in the UK, but in Western Europe. During the past sixty years Dorset's oil industry has attracted many superlatives.

- The Kimmeridge oil well has been in continuous production for sixty years, making it the longest continuously producing onshore oil well in the UK, producing over 3.5 million barrels of oil to date.
- One of the deepest onshore oil exploration wells drilled in the UK was drilled just outside the Dorset village of Winterborne Kingston by the UK's Department of Energy during the winter of 1976/77. It reached a true vertical depth of nearly 10,000 feet, just less than 2 miles.
- The longest step out well in the world at 35,000 feet (10.7 kilometres) was drilled at Wytch Farm oilfield during BP's operatorship in 1999. This record held for many years.
- The Wytch Farm oilfield has proved to be Western Europe's biggest onshore oilfield, having produced nearly half a billion barrels of oil to date.
- The prestigious Queen's Award for Environmental Achievement was awarded to BP in 1995 for its innovative and environmentally sensitive development of the Wytch Farm oilfield.

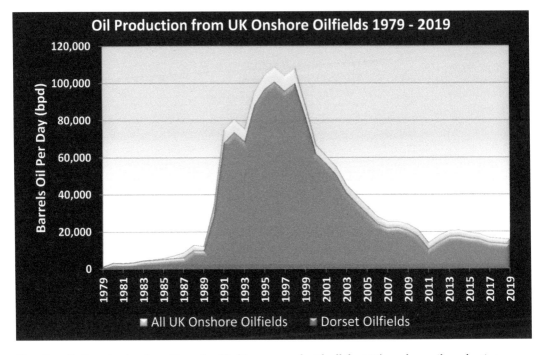

Timeline of oil production from Dorset's oilfields compared with all the UK's onshore oil production. At the peak of production from 1995 to 1999 Dorset's oilfields contributed about 93 per cent to the total UK onshore oil production. (Author, contains information provided by the OGA)

Today, Dorset's oil industry has declined somewhat, with the larger oil companies giving way to smaller independents and oil exploration moving offshore. However, oil is still being produced at three of the four Dorset oilfields, Kimmeridge, Wareham and Wytch Farm, amounting to around 13,260 barrels per day at mid-2019.

Field Name	Oil Initially in Place million barrels /reference	Start-Up Date	Peak Oil Rate bpd (Date)	Status at 2019
Kimmeridge	10–25 /1	1960	489 (1972)	Producing
Waddock Cross	30+ /2	2014	10 (2014)	Shut-in
Wareham	21 /3	1991	2,415 (1991)	Producing
Wytch Farm	1000+ /4	1979	107,813 (1996)	Producing

1 Gluyas, Evans, Richards
2 Egdon Resources plc
3 Underhill & Stoneley
4 MacGregor & Reid

bpd: barrels per day

Key data for the four Dorset oilfields. The oil in place figures are estimates given by the people referenced. The peak oil rates are averages for the peak months in the years quoted. (Author)

2

Technical Background

Some technical background is helpful in understanding the history of oil exploration and production in Dorset. The oil industry, like all other industries, has its jargon, acronyms and technical phraseology, much of which is based on the history of the industry itself. The purpose of this chapter is to provide some explanation of the terms, equipment and techniques mentioned in later chapters.

Oil and Gas Properties

Crude oil consists of a complex composition of hydrocarbon components. Each component is an organic compound made up of carbon and hydrogen atoms. The simplest and lightest hydrocarbon has just one carbon atom and four hydrogen atoms. It exists as a free gas called methane, but it can also dissolve in oil. All crude oil contains some dissolved gas. In this respect methane is similar to carbon dioxide gas, dissolving in water to produce sparkling water.

The more carbon atoms a component has will determine how heavy it is compared to others. For example, a component with ten carbon atoms will be lighter than one with twenty carbon atoms. The properties of a given crude oil are determined by the mix of light and heavy hydrocarbon components in its composition. If this mix is biased towards the lighter components then the crude will be described as light oil. If biased towards the heavier components it will be described as heavy crude. However, all crude oil is less dense than water, which means it will float on top of water.

The colour of a given crude oil is largely determined by the composition of hydrocarbon components within it. Most crude oils are coloured from dark brown to black in colour. Another important property of crude oil is its ability to flow, which is determined by its viscosity. Light oil will have a viscosity more like water and will flow more readily than heavy oil. Heavier oils will have high viscosities and flow more like treacle.

All crude oils have some inorganic compounds as part of the mixture of components making up the oil. These usually consist of nitrogen, carbon dioxide and hydrogen sulphide. If carbon dioxide and hydrogen sulphide are present in quantities of more than

Photograph of crude oil being poured, like water, from a flask into a beaker. (Pablo Paul/Alamy Stock Photo)

one or two per cent then the oil will be regarded as sour. Crude oil from Dorset contains little of these components and includes a high proportion of lighter hydrocarbons. Dorset oil is, therefore, regarded as light, sweet crude.

Oil Formation, Migration and Trapping

Oil reservoirs are not underground lakes of oil. Oil is contained within the pores of rocks rather like water contained in a water filled sponge. Gas is similarly contained within a gas reservoir. Porosity is a measure of how much of a rock is pore space. Permeability is the measure of how easy it is for fluids to move through the pores. These reservoir rocks are often buried thousands of metres below the ground. At such depths pressures and temperatures are much higher than those at the surface; both increase with depth. Since the advent of oil and gas production from shales, the oil industry has found it necessary to label oil and gas reservoirs as either 'conventional' or 'unconventional'.

Conventional hydrocarbon reservoirs contain mobile oil or gas, which can flow readily into wells drilled into them. Millions of years ago the oil or gas was generated from source rocks of organic rich shales buried much deeper than the reservoirs above. At depths of around 3,000–4,000 metres (9,800–13,100 feet) temperatures and pressures would have

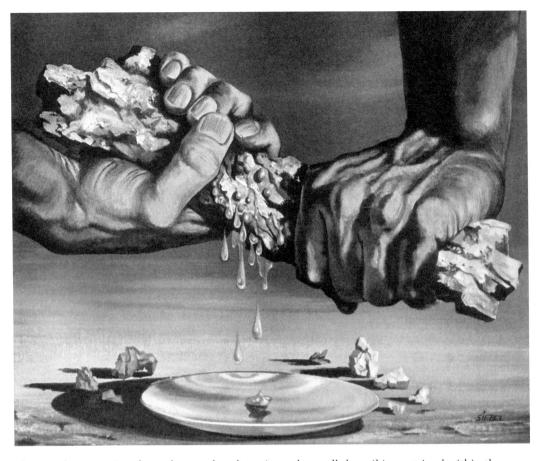

The artist's impression shown here makes the point rather well that oil is contained within the myriad pores of rock, rather like water in a sponge. If only one could wring out an oil-filled rock like a sponge! (© The Picture Now Image Collection/Mary Evans Picture Library)

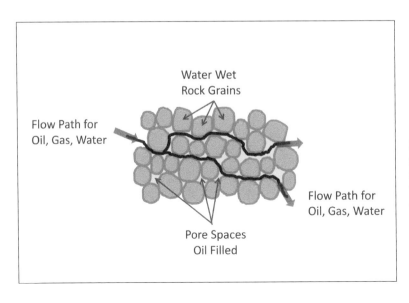

Schematic showing how oil moves through the pore structure of reservoir rock. Some oil is permanently trapped in 'dead end' pore spaces. (Author)

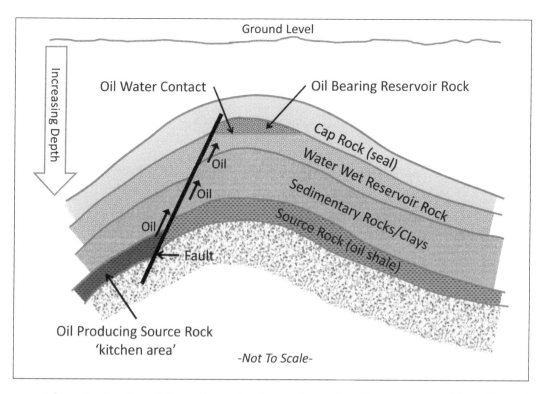

Schematic showing oil formation, migration and trapping. The pressure cooking effects of depth cause the breakdown into oil of organic matter in the shale source rock. Oil migrates upwards to structural highs where it is trapped by a seal such as clay. (Author)

often been high enough to cause the organic material in the shale to breakdown into mobile oil and gas. Over geological timescales the oil and gas migrated upwards, due to buoyancy effects, along fault planes and other pathways to become trapped in rocks at structural high points. These reservoir rocks are often porous sandstones or limestones, permeable enough for the oil and gas to be mobile.

Unconventional hydrocarbon reservoirs contain oil and gas trapped in the same source rock, usually shale, in which they were formed, hence the terms 'shale oil' and 'shale gas'. Such shales have very small pores and are, therefore, not very permeable. This means that the oil and gas trapped within are not very mobile and cannot migrate. Unconventional reservoirs require artificial pathways to be opened up to allow the oil and gas to flow into wells drilled into them. Such pathways are created using the technique known as hydraulic fracturing or 'fracking' as it is often called.

Drilling Rigs, Drill Bits and Drillers

The iconic picture of a drilling rig is often seen in newspapers, magazines and on television. Such images somehow seem familiar to just about everyone. What such a rig consists of and how it works is, perhaps, less familiar.

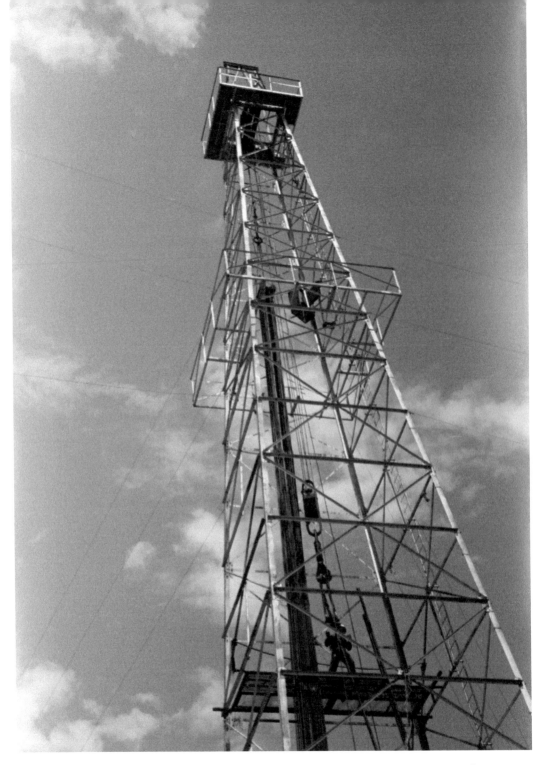

Photograph looking up through the steel derrick of a typical onshore drilling rig in use during the 1940s to 1990s. Stands of drill pipe awaiting connection are stacked vertically inside the derrick. Rigs like this one, capable of drilling boreholes to depths of around 3,000 metres (10,000 feet), were used in Dorset. (© Mary Evans/Glass House Images)

A steel-framed derrick supports the drill string and allows it to move vertically up and down by means of pulley blocks and steel cable. The drill string consists of 30 feet sections of steel piping screwed together, with a drill bit at one end and a splined hollow shaft, called the 'Kelly', and a swivel at the other. The Kelly passes through and engages with a hexagonal cut out (bushing) in the drilling table, which can be rotated by means of an electric or diesel motor drive. The whole assembly allows the drill bit to move up and down during rotation. A drilling fluid, often referred to as 'mud', is pumped down the drill string and emerges through the drill bit into the borehole being drilled. The mud passes back up through the annulus to surface thereby completing the circulation. The purpose of the mud is threefold:

- To cool the drill bit.
- To remove the drill cuttings and bring them to surface where they are separated from the mud.
- Provide a degree of over-pressure to prevent any fluids blowing out from the formation bring drilled.

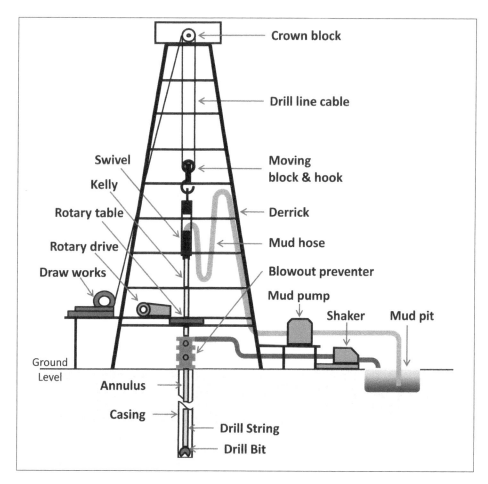

Schematic showing the parts of a typical onshore rotary drilling rig used during the twentieth century. (Author)

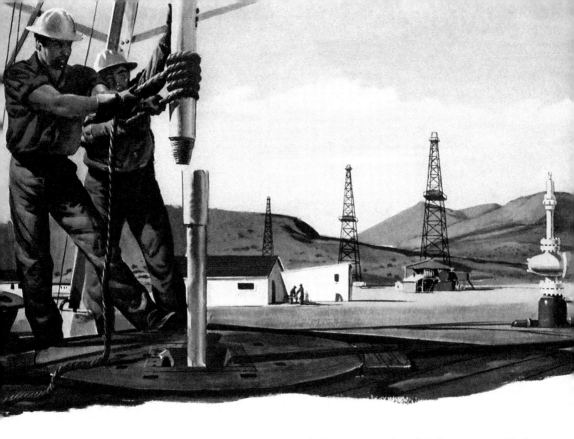

Artistic interpretations of rig workers connecting drill pipe. Lengths of drill pipe are added as the borehole is deepened. Drilling stops for this work. The drill pipe passes through the stopped rotary table at the workers feet. The rope is symbolic of tools used to connect pipe. (© The Picture Now Image Collection/Mary Evans Picture Library)

As the borehole is deepened, smaller diameter bits are used and concentric steel casing of decreasing diameter is used to line the borehole to prevent it from collapsing. A blowout preventer is installed, which in an emergency will seal off the drill string and the top of the surface casing to stop any sub-surface fluids from escaping to the surface.

Drill bits commonly used for drilling oil and gas wells come in two types: roller cone and fixed head. As the names suggest, the roller cone type has moving parts and the fixed head type does not. Both types of bit rotate at the end of the drill string and are designed to cut chips of rock at the end of the borehole. They have steel bodies that carry the cutter assemblies and come in diameters expressed in inches from 4 to 36 inches.

The roller cone bit has its cutters of hardened steel, or tungsten carbide, fixed to three steel cones, which can rotate within the body of the bit as the bit itself rotates. This bit type was introduced in 1933 by Baker Hughes, an American oil service company. Fixed head cutter bits are of more recent origin. They have cutting teeth of industrial diamonds set within their metal bodies. They are often advertised as Polycrystalline Diamond Cutter (PDC) bits.

In the early days of onshore oil exploration in the UK, oil companies employed their own drilling rigs, often lorry mounted, to drill relatively shallow boreholes. Nowadays, oil

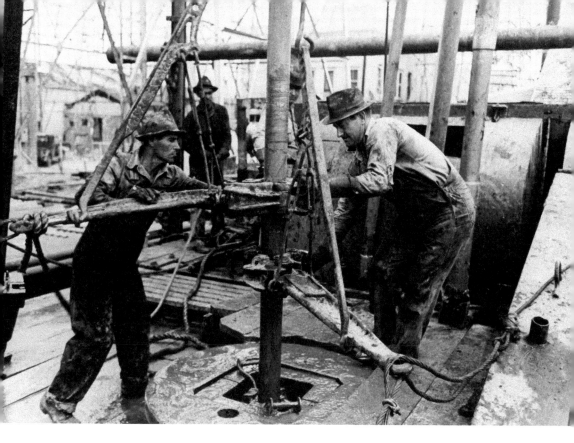

Above: Photograph of mid-twentieth-century rig workers connecting drill pipe using large pipe wrenches called 'tongs'. The drill pipe already in the borehole is wedged in place as the new length of pipe is added. (Mary Evans/Everett Collection)

Right: Photograph of two types of drill bit. The gold colour one is a Fixed Head Polycrystalline Diamond Cutter (PDC) bit. The smaller green one is a Roller Cone bit. (Agencja Fotograficzna Caro/ Alamy Stock Photo)

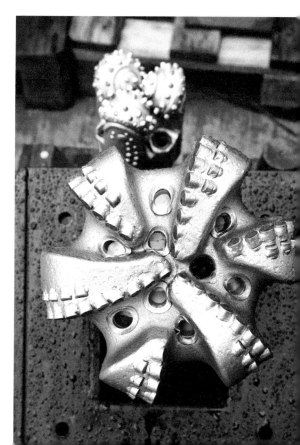

companies, regardless of size, employ drilling contractors who own the rigs, deploy them and employ specialist staff to man and maintain them. A close relationship between the oil company and drilling contractor is needed to ensure safe and efficient operations at the drill site.

Wells

From the perspective of the oil industry, a well is a hole bored into the ground to search for and produce hydrocarbons, oil and gas, from rocks deep below the surface.

A typical well consists of a series of concentric boreholes of decreasing diameter with depth. Each portion of the well is cased with steel pipe of appropriate diameter to match the borehole. If the well is a development well for oil or gas production, then the innermost casing will be perforated at a depth opposite the hydrocarbon producing zones. In a conventional oil reservoir this allows the oil or gas to flow freely into the lowest part of the well. Oil production wells are fitted with production tubing, which runs from just above the perforated interval to the surface wellhead. The wellhead is where control valves, pressure monitors, test equipment and take-offs to flowlines are located.

Since the 1920s it has been possible to deliberately change the well path from vertical to just about any path, including horizontal. This technique is known as directional drilling. It is accomplished by steerable devices mounted at the end of the drill pipe, behind the

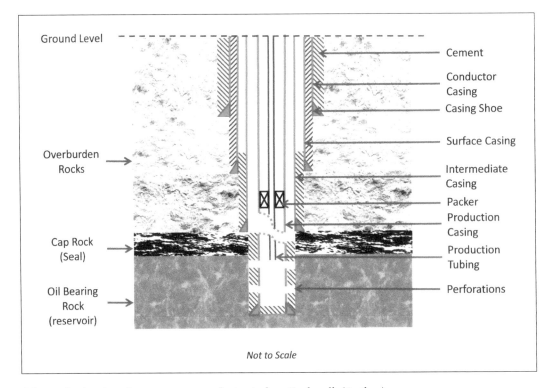

Schematic showing the arrangement of a typical vertical well. (Author)

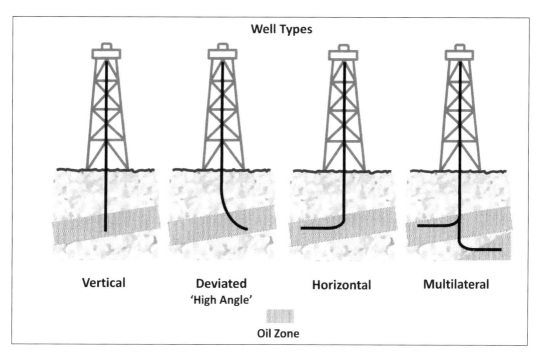

Well Types

Vertical Deviated 'High Angle' Horizontal Multilateral

Oil Zone

Schematic showing different types of well. Wells start with a vertical borehole. Further drilling can deliberately alter the path of the borehole to become horizontal. Branches can be added to the initial borehole to get a multilateral well. (Author)

drill bit. With the introduction of digital technology, these devices allow the well path to be 'steered' with great accuracy, enabling targets to be reached many kilometres from the drill site. Thus, it is possible to drill a well deep under the sea and many kilometres from a drill site located onshore. Such wells are known as 'step out' or 'long reach' wells.

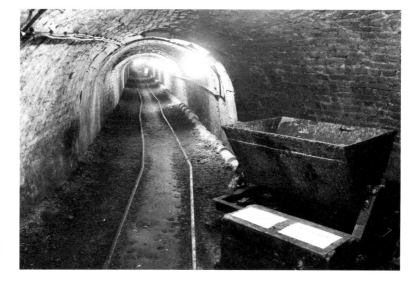

Photograph of Tar Tunnel, Ironbridge Gorge Museum, Coalport, Shropshire, which provides an analogue for a functioning oil well. (Author)

It is possible to drill a number of branching well bores from the main borehole. Such wells are known as multilateral wells and they have been used since the early 1950s, but it is only recently they have become more common. It is more cost-effective to add a lateral branch to an existing well than to drill a new well in order to expose more of the reservoir to production.

The Tar Tunnel, Ironbridge Gorge Museum, Coalport, Shropshire, provides an analogue model of a functioning oil well. Originally dug in 1787 to connect nearby coal mines with the Coalport canal, the tunnel passed through a reservoir rock containing viscous oil called bitumen. Not surprisingly, further tunnelling was abandoned in favour of extracting the bitumen. Until recently it was possible to enter the tunnel and see the bitumen oozing through joints in the brick lining. This provides an analogue for oil flow into a well bore. The tunnel is the well bore, the bricks, the casing and the joints between the bricks the perforations in the casing.

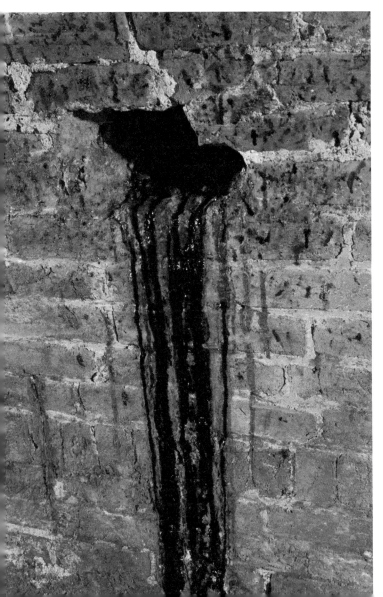

Photograph of Tar Tunnel, Ironbridge Gorge Museum, Coalport, Shropshire, showing liquid bitumen seeping through joints in brickwork lining, providing an analogue for oil flowing from reservoir rock into a well. (Steve Sant/Alamy Stock Photo)

Oil and Gas Exploration

The process of exploring for oil and gas is a complex one. In the early part of the twentieth century, the process was often started by geologists and palaeontologists following up stories of oil and gas seeping out of the ground at certain locations. These hydrocarbon seeps were often known to local populations for generations, but their significance remained unrealised. This was followed by surveys of the surrounding countryside, studies of rock formations, fossils, and rock cuttings from test boreholes. Before the use of seismic technology, surface geological mapping was the only way to 'view' the structural geology of potential hydrocarbon systems trapped deep below the ground. From such maps the exploration geologist could identify target locations for exploration wells to be drilled.

Move forward fifty years to the middle of the twentieth century and by this time seismic technology had become an invaluable tool in oil and gas exploration. A seismic survey involves sending low frequency sound waves into the ground and recording the reflections coming back to the surface from the subsurface rock strata. Long lines of geophones, 20 metres apart and hundreds of metres in length, are placed in ground contact to detect the wave signals reflecting back. These signals are then analysed using computers to produce images of the subsurface geological strata. Interpretation of such sections can reveal any potential geological structures that might contain oil or gas.

However, the only way to confirm the presence of oil and gas is to drill an exploration well at the chosen location. Exploration wells are usually vertical and are sometimes cored to bring a sample of rock to the surface for closer examination. In any case,

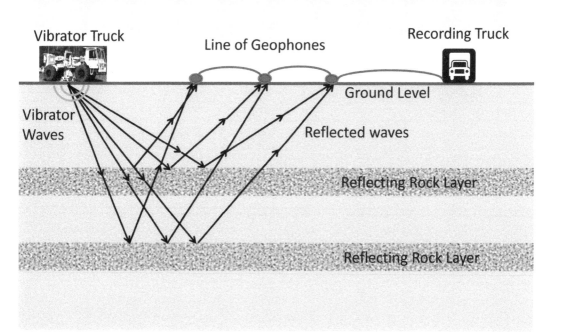

Schematic showing key features of a seismic survey. (Author)

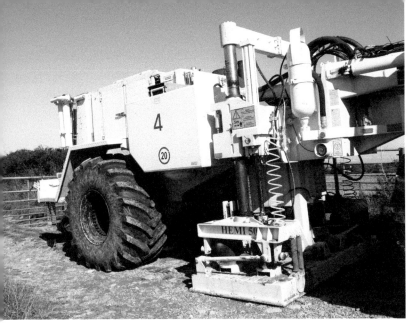

Photograph of a seismic vibrator truck. The vibrator plate is lowered to the ground, under the truck, to provide a source of low frequency sound waves that penetrate below the surface. (Author, photo courtesy of Geofizyka Torun)

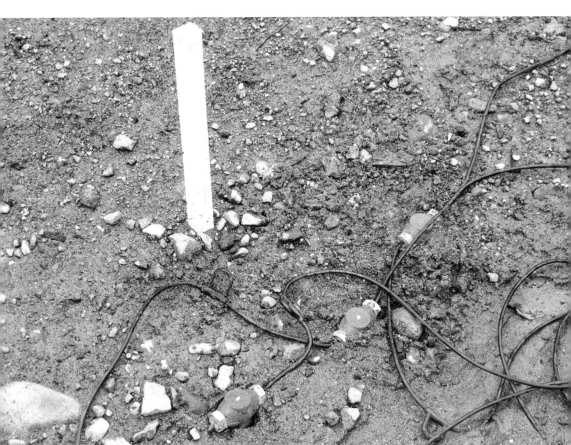

Photograph of orange geophones in situ, used to pick up the sound waves reflected from the rock strata below ground. (Peter Righteous/Alamy Stock Photo)

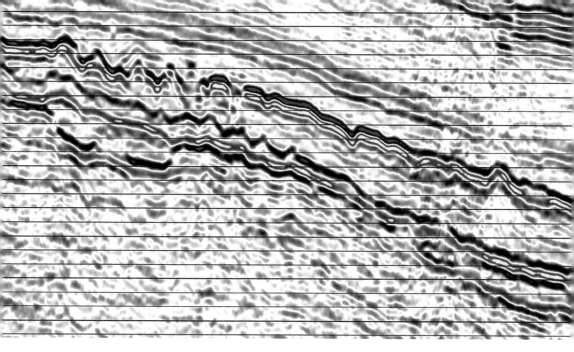

Photograph of a typical computer-generated seismic section from the signals picked up by the geophones. Interpretation of many such sections can reveal geological structures that might contain oil or gas. (Author)

rock cuttings brought to the surface in the drilling mud are diligently examined under ultraviolet light for signs of oil. Rock saturated with crude oil will give off a characteristic fluorescence.

Once the exploration well has reached the target location, probes, called logging tools, are lowered by wire into the borehole. Their purpose is to measure (log) the properties of the rocks through which the borehole passes. In particular, the oil, gas and water content of the rock strata can be determined. Combining these measurements with the mapping derived from seismic gives an estimate of the total oil or gas in place.

Oilfield Development

There are several traditional methods of developing oil reservoirs, such as natural depletion and water flooding. Together, these form what is called conventional oil recovery methods to distinguish them from unconventional methods of extracting oil and gas such as hydraulic fracturing, sometimes called 'fracking'. A conventional oil or gas reservoir is one in which the hydrocarbon-bearing rock is permeable enough to allow the oil or gas to flow freely into the well bore. In such reservoirs hydraulic fracturing is not required. All the oilfields in Dorset are conventional ones.

Natural depletion is usually the initial method of developing onshore, conventional oilfields. This involves drilling a number of development wells into the oil-bearing rock and allowing the oil to flow freely into them under its own pressure. Development production

wells differ from exploration wells in that they are fitted out with permanent production tubing, which conveys the oil to the surface well head. If the reservoir pressure is high enough, the oil will arrive at the wellheads and pass through flowlines to processing facilities, where oil is separated from the associated gas and any water. If the reservoir pressure is too low, then pumps are needed to assist in bringing the oil to the surface. On shore, two types of pump are used: the ubiquitous 'nodding donkey', otherwise known as a beam pump or pump jack, and the electrical submersible pump (ESP).

In a pump jack, a pivoted beam converts the rotary motion of the prime mover, a diesel or electric motor, to a vertical up and down movement of a steel rod. This rod passes through the well head, inside the production tubing and is connected to a piston inside the pump barrel. The pump barrel is connected to the reservoir end of the production tubing. The piston inside the pump barrel is moved up and down by the rod. Valves inside the pump barrel and the piston allow oil to be alternately drawn into the pump and then discharged into the production tubing to surface.

As the name suggests, an ESP is placed at the bottom of a development well. The electric motor is connected by an insulated wire cable to an electrical power source at the surface. The motor drives a series of impellers, which together draw oil in from the reservoir rock and discharge it at pressure into the bottom of the production tubing, thereby pushing

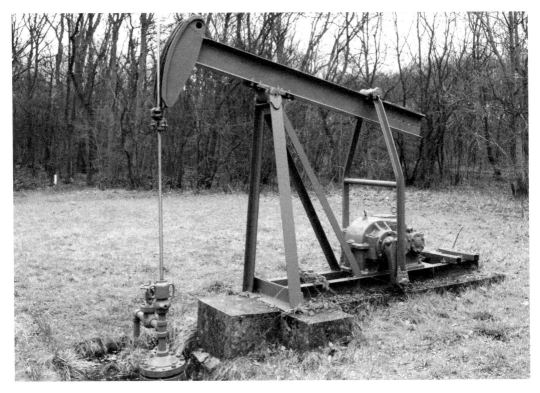

Photograph of an oil pump jack, 'nodding donkey', at Dukes Wood Oil Museum Nottinghamshire. A motor and crank (right) cause the pivoted beam to oscillate. This causes the steel rod to move up and down through the well head (bottom left), thereby activating the pump mechanism at the bottom of the well. (Lowefoto/Alamy Stock Photo)

oil to the surface. ESPs work in any type of well, from vertical to horizontal. They are most efficient at the higher rates of oil production, typically measured in thousands of barrels per day.

After a period of natural depletion, the reservoir pressure and oil rates will have dropped. Therefore, a controlled water flood of the oil reservoir might be initiated to restore both pressure and oil production. In this method water is injected at pressures below the fracture pressure of the reservoir rock. Indeed, operators injecting water into conventional oil reservoirs are under regulatory obligations to ensure the natural fracture pressures of the rock are not exceeded. The purpose of a water flood is to provide pressure support and drive oil, in a controlled way, towards the production development wells. To be clear, conducting a water flood in a conventional oil reservoir is not a form of hydraulic fracturing or 'fracking'.

Reservoir fluids pass from the production wells to the surface processing facilities, where the oil, water and gas are separated. For small onshore fields the produced oil is transported by road to a refinery. Any produced water can be reinjected into the reservoir. The associated produced gas can be used to fuel electricity generation or piped into the national gas grid. Large onshore oilfields will have enough oil and gas production to warrant transportation by pipeline to export terminal or refinery.

Transport of Oil and Gas

There are four methods of transporting oil or gas in quantity from field to refinery – pipeline, road tanker, rail tanker and ship tanker. All four methods have been in use since the early part of the twentieth century and are still in use today.

Pipelines are used both onshore and offshore and are often trenched for most of their length. They are made up of sections of steel pipe welded together. The anticipated volumetric throughput will determine its diameter, usually measured in inches. Pipeline diameters can be anything from 8 inches to a massive 48 inches as used in the Trans-Alaska Pipeline, which achieved a peak daily flow of around 2 million barrels over a distance of 1,288 kilometres (800 miles). The experience gained by the likes of BP, Exxon and Shell during the 1930s in building oil pipelines across the deserts of the Middle East has since led to these remarkable feats of pipeline engineering elsewhere.

Road tankers are usually used to transport small quantities of oil from individual well sites direct to refineries or central gathering stations for processing and onward transmission. During the 1920s, Shell and BP in particular began to develop road vehicles to carry oil and petroleum spirits in bulk. These early vehicles had capacities of around 1,000 imperial gallons (twenty-nine barrels), small by today's road tanker capacities. Modern liquid road tankers for use in the UK come in a range of capacities from 15,000 litres (ninety-four barrels) to 42,000 litres (264 barrels). Gas, too, can be moved around by road tanker in the form of liquefied petroleum gas (LPG) using vehicles of similar capacities.

As early as 1925 BP was using oil tanker rail wagons to transport petroleum spirits out of its oil refinery in Llandarcy, Wales. In 1963 BP and Shell Mex formed a jointly owned rail tanker fleet on a long-term contract with British Rail. Each tanker rail wagon could carry 30 tons of liquid, which is roughly 220 barrels of crude oil.

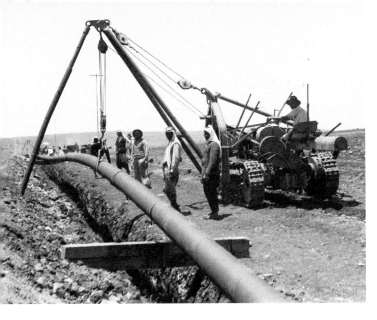

Photograph showing the laying of a welded oil pipeline from Kirkuk oilfield, Iraq, 585 miles (942 kilometres) to the Mediterranean Port of Haifa. The pipeline was opened in 1935 and closed 1948. Oil pipelines are laid in much the same way today. (Mary Evans/Everett Collection)

The bulk carrying of oil by seagoing vessels can be traced back to the latter part of the nineteenth century. The Shell oil company began life as a shipping company, transporting oil in wooden barrels, among other cargoes, in the late 1800s. To improve efficiency they came up with the idea of incorporating large metal tanks as an integral part of the ship's cargo space. Thus an oil tanker ship called the *Murex* was born, named after the sea shells the company also carried. This vessel made its maiden voyage through the Suez Canal in 1892. Inevitably, such vessels grew in size to reach the Ultra Large Crude Carriers (ULCC) now in use around the world, with crude oil-carrying capacities measured in millions of barrels.

Lantern slide, *c.* 1925, showing the loading of BP rail tanker wagons at BP Llandarcy oil refinery, Swansea, Wales. BP used rail tanker wagons to transport oil from Dorset oilfields during the 1980s. (Mary Evans Picture Library/Lynne's Collection)

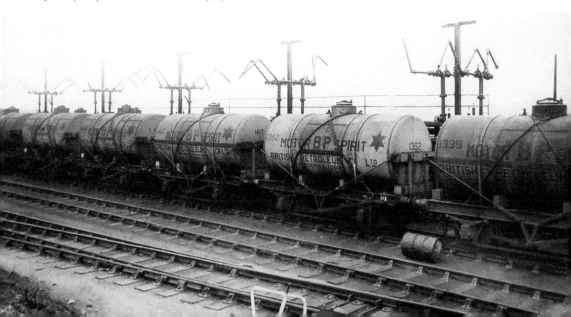

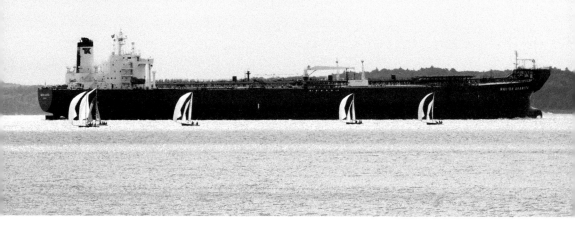

Photograph of a crude oil tanker ship seen on the Solent, southern England, during Cowes Week, August 2010. The yachts sailing by give an idea of scale. (Peter Titmuss/Alamy Stock Photo)

The transport of natural gas by ship has a more recent history. In the late 1950s it became commercially viable to liquefy natural gas at the site of production. The first ever shipment of liquefied natural gas (LNG) occurred in 1959. A ship called the *Methane Pioneer*, chartered by Shell, carried out its maiden LNG transportation from Louisiana, USA, to Canvey Island, UK gas terminal. Here it discharged its cargo of 5,000 cubic metres of LNG. Since then the global LNG tanker fleet has grown to hundreds of vessels with individual LNG-carrying capacities in the range 1,000 to 250,000 cubic metres.

At various times during its operatorship from 1959 to 2011, BP used all four methods, road, rail, pipeline and ship, to transport oil and gas from its Dorset oilfields to refineries and the UK gas network.

Organisation of the UK Oil Industry

Perhaps surprisingly, oil found under land in the United Kingdom belongs to the state not the landowner. To extract such oil a licence is required from the UK government of the day. In the UK, licensing to explore, extract and develop hydrocarbons onshore has evolved into a system whereby all three activities can be undertaken under one licence, known as a Petroleum Exploration and Development Licence (PEDL). The land is divided into separate licence blocks. Previously, separate licences were issued for exploration and production, the latter given an acronym PL. Many of these older licences are extant. For example, PL089 is the licence block containing the Dorset oilfields Wareham and Wytch Farm, both discovered some time ago, but currently producing.

The UK's Oil & Gas Authority (OGA) is responsible for issuing these landward licences to appropriately qualified companies. The licence holder takes on the role of 'Operator' and is responsible for all workings and safety on the licence block. The operator will often be part of a consortium of other companies who will become partners in the joint venture.

However, obtaining a PEDL is not the end of the licencing process. It is necessary for the operator to engage with local government to obtain additional planning consents before

commencing any works on the designated licence block. An operator holding a PEDL is not automatically granted such consents. Consequently, this can lead to a long drawn-out battle with local planning authorities, and local pressure groups, in order to acquire the necessary local planning consents.

Economics and the Price of Oil

Before going ahead with an oil or gas field development, its economic viability needs to be assessed. The economic calculations of a proposed oilfield development centre on a number of key parameters. One of these is a credible oil production profile forecast for periods typically up to thirty years. Equally important is a forecast of the price of oil over the same period. However, the price of a barrel of oil is difficult to forecast. Although it is determined by international markets, influenced mainly by supply and demand, other factors such as wars, international politics, global economics and catastrophic natural events can also have an influence. This gives rise to fluctuations in the oil price not only from year to year but from day to day and sometimes big downturns.

There are financial costs to bring an oil or gas field into production. These costs fall into three categories: capital expenditure (CAPEX), operating expenditure (OPEX) and the inevitable tax charge. CAPEX is the sum of all the costs associated with the field's development. For a large oilfield, CAPEX can run to billions of US dollars. OPEX, on the other hand, is about accounting for the day-to-day expenses associated with running a producing oilfield. Once the oilfield comes into profit then there will be a tax charge on the profits accruing from the sale of the oil and gas. Here, in the UK, the maximum oil tax rate is currently (2019) 40 per cent, although previously it had been higher.

Having arrived at estimates of CAPEX, OPEX and tax together with predictions of oil production and the oil price, calculations can then be made to discover whether or not the proposed oilfield development will be economically viable for its lifetime of up to thirty years.

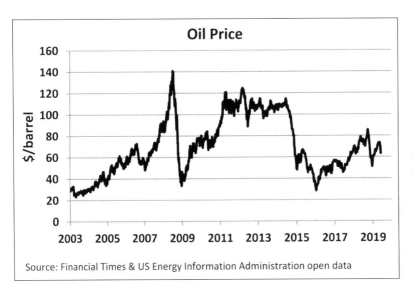

Source: Financial Times & US Energy Information Administration open data

Chart showing the price of oil from 2003 to 2019 (Author. Data sources: *Financial Times,* US Energy Information Administration)

3

Geological Setting

The Wessex Basin is one of two hydrocarbon productive basins in the south of England. Onshore, it is more or less centred on the county of Dorset. To the south, the Wessex Basin extends offshore to encompass parts of the Isle of Wight. The geology of the Wessex Basin has been studied since the beginning of the nineteenth century. An up-to-date description has been given in Oil and Gas Authority publications. Much of our present understanding of the geology of the Wessex Basin has come from studies carried out in Dorset.

The world-renowned heritage coast from Dorset to East Devon has provided, and continues to provide, petroleum geologists with a wide variety of cliff outcrops of sedimentary rocks and clays to study. These rocks range in age from the earliest, laid down during the Triassic period, 250 million years ago, to the much younger rocks of the

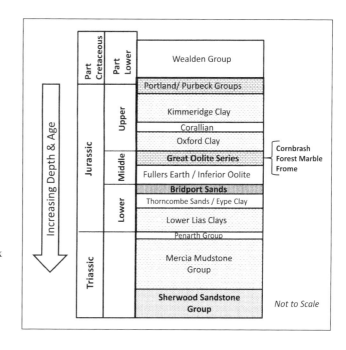

Schematic showing part of the stratigraphy of the Wessex Basin simplified to highlight the principal shales, source rocks and oil reservoir rocks mentioned in this book. (Author)

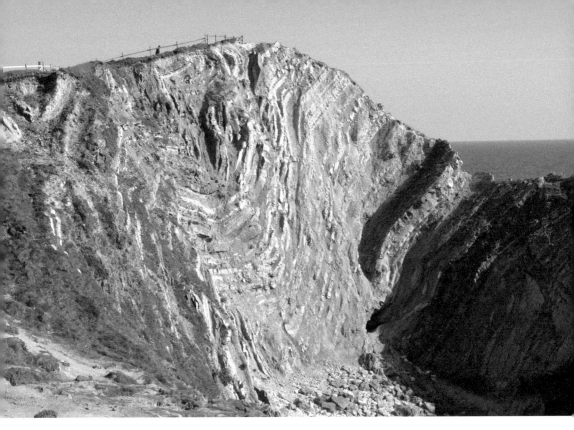

Photograph of the 'Lulworth Crumple', Stair Hole, Lulworth, showing the folding of rock strata formed by geological events subsequent to deposition. (Author)

Cretaceous period, a mere 100 million years ago. Generally, sediments are laid down on top of each other with the younger sediments compressing the older ones underneath. Thus a 'layer cake' arrangement builds up over time, with the different rock types and layer thicknesses determined by the environments in which the sediments were formed. From around the beginning of the twentieth century geologists have represented the succession of rock layers (strata) in diagrammatic form using the stratigraphic column.

An up-to-date full stratigraphic column for the Wessex Basin has been set out by a number of authors. For the purposes of this book, a slightly truncated and simplified form has been drawn to set out the relative stratigraphic positions of the principal shales, source rocks and oil reservoirs of Dorset. As a result of events, subsequent to deposition, rock strata can be folded to form a dome-shaped structure or displaced by faulting. This means that the depth of a given rock layer can vary from one location to another.

Oil Seeps

Many of the early field studies of Dorset's geology, from around 1890 to 1950, were mainly confined to a stretch of coast from Weymouth to Swanage. In 1937 two geologists, Lees and Cox, from the D'Arcy Oil Exploration Company found oil seeps along this part of the coast

at Osmington Mills, Stair Hole Lulworth and Mupe Bay. They realised the significance of these seeps from their recent experiences in Persia (now Iran) and Iraq. In both countries, geological studies of such oil seeps led to the discovery of multimillion barrel oilfields. Lees and Cox published their findings and analyses of the Dorset oil seeps in the 1937 edition

Right: Photograph of the oil seep at Stair Hole, Lulworth. Oil seeps quite naturally from an outcrop of sands of the Wealden Group. Seeps like this prompted the drilling of the early exploration wells in Dorset. (Author)

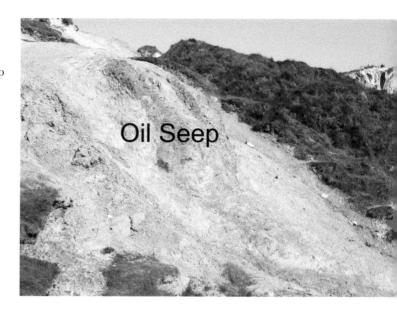

Below: Photograph of oil seeps at the base of cliffs just east of Osmington Mills. Here, oil seeps naturally from an outcrop of the Bencliff Grit, staining the sandstone a chocolate brown colour. (Author)

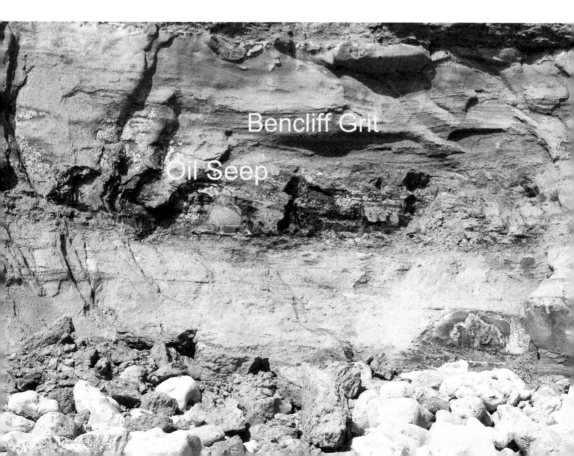

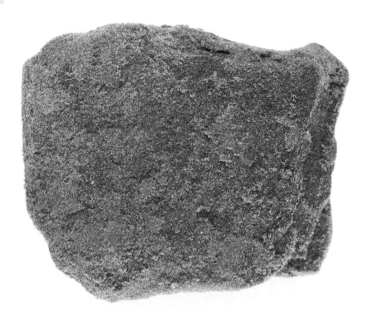

Photograph of a piece of oil-stained Bencliff Grit sandstone from the beach at the base of cliffs just east of Osmington Mills. (Author)

of the *Journal of the Geological Society*. They surmised that accumulations of oil could lie at depth just inland of the coast between Osmington and Kimmeridge. Moreover, the oil reservoirs would be indigenous to rock strata of the Lower Cretaceous and Upper Jurassic periods buried below the surface. For the source rock of this oil they chose the organic rich layers of the deeper Oxford Clay Formation.

During the years 1936 to 1939 the D'Arcy Oil Exploration Company drilled four conventional exploration wells at Broadbench, Ringstead, Poxwell and Chaldon Down respectively. None of these wells went deeper than 375 metres (1,230 feet) true vertical depth subsea and none of them produced mobile oil to surface, although oil shows were present. Without the aid of seismic technology and drilling rigs capable of drilling deeper, these pioneers of oil exploration in Dorset could not have known that working oil systems did exist in strata much deeper.

Cornbrash Limestone

Oil exploration drilling in Dorset ceased for the duration of the Second World War, but recommenced in 1946. However, it took a further thirteen years before oil in commercial quantities was found by BP at their Kimmeridge 1 well.

The Kimmeridge 1 conventional, vertical well was completed in April 1959 and was drilled to a total depth of 528 metres (1,733 feet) subsea. The well entered the Middle Jurassic Great Oolite Series of rocks and encountered mobile oil in the Cornbrash Limestone. The Cornbrash bed is made up of rubbly limestones, which outcrop as low cliff sections at locations along the north bank of the Fleet waterway behind the Chesil Beach. The rock itself has little porosity and is almost impermeable, which means most of the mobile oil is in the natural fissures. At reservoir level these fissures are much narrower than at the surface due to pressure exerted by the rock strata above. Nevertheless, these

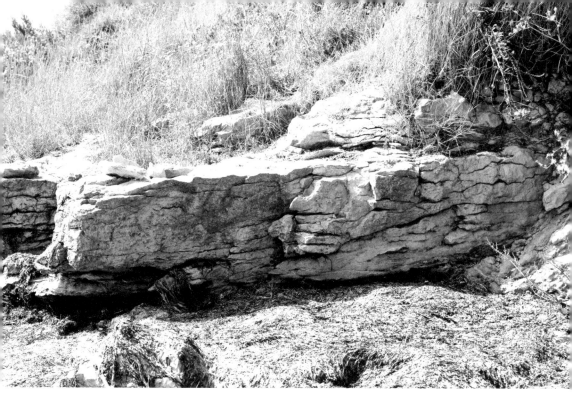

Above: Photograph of a low cliff section outcrop of Upper Cornbrash Limestone at East Fleet, on the north bank of the Fleet waterway. This is an analogue of the Kimmeridge oil reservoir. Most of the mobile oil in the reservoir will be in the natural fissures. (Author)

Right: Photograph of a sample of Upper Cornbrash Limestone on the beach at East Fleet. The rock itself has low porosity and in the reservoir forms the rock matrix bearing little oil. Sample size approximately 9 x 7 cm. (Author)

fissures are very much more permeable than the rock matrix and, therefore, provide pathways for the oil to flow into the well. The Oxford Clays in the Upper Jurassic provide the seal to the Kimmeridge oilfield.

Bridport Sandstone

In 1964 a working oil system was discovered by BP just outside the town of Wareham. The Wareham 1 conventional, vertical well was drilled to a total depth of 1,074 metres (3,524 feet)

subsea. It encountered a thin section of oil-bearing Bridport Sandstone. This was confirmed by a second well, Wareham 2, drilled by BP in 1965. It encountered the thick oil-bearing Bridport Sand Formation at 865 metres (2,839 feet) subsea. The Bridport Sandstone forms an oil-producing reservoir at the Waddock Cross, Wareham and Wytch Farm oilfields.

The Bridport sandstones outcrop as vertical cliff sections almost continuously from Burton Bradstock to West Bay, Bridport. They were laid down as sediments in a marine environment during the Lower Jurassic period, around 180 million years ago. On exposure, the sandstone weathers to a yellow/orange rust colour due to the oxidation of free iron and iron salts contained within the matrix of fine grains of sand making up the rock. Rock cores taken directly from the reservoir are grey/blue or sometimes purple in colour.

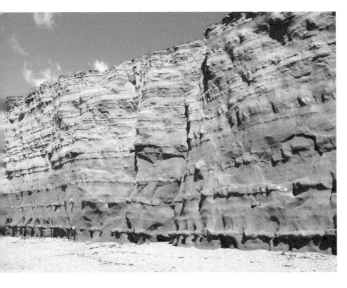

Photograph of a cliff section outcrop of Bridport Sandstone at Burton Bradstock. It is an analogue of the oil-producing Bridport Sandstone reservoir in the Wytch Farm, Wareham and Waddock Cross oilfields. (Author)

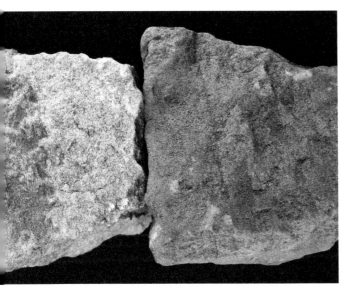

Photograph of two rock samples of Bridport Sandstone on the beach at Burton Bradstock. The lighter one is calcite cemented sandstone from one of the narrow bands that protrude from the cliff face. It contrasts with the porous rust coloured sandstone that carries the oil in the Bridport reservoir. Sample size approximately 6 x 6 cm. (Author)

The cliff section shows almost continuous thin bands of lighter coloured rock that appear in cycles getting closer towards the top. The bands are made of calcite cemented sand, which is hard and almost impervious; hence they weather less than the sandstone and so protrude from the cliff face. In the oil reservoir, these bands form baffles to vertical flow of fluids, making the design and placement of production wells problematic.

Cliff sections provide a valuable visual insight into the spatial arrangements of the rock strata making up an oil or gas reservoir deep underground. In addition, they can provide an analogue for physical rock properties such as porosity and permeability.

Sherwood Sandstone

In 1978 British Gas discovered oil in the Sherwood Sandstone Group at the Wytch Farm oilfield. The well, designated D2, encountered mobile oil at a depth of 1,559 metres (5,115 feet) subsea, nearly a mile down. This group of rocks consists of red, yellow and

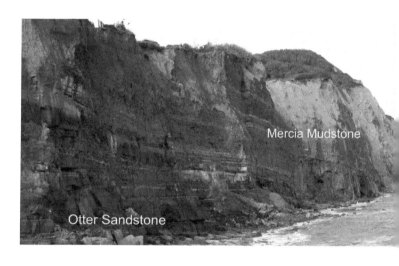

Photograph of a cliff section outcrop at the eastern end of Sidmouth seafront. It shows the Mercia Mudstone, which forms the cap rock seal to the Sherwood oil reservoir at Wytch Farm oilfield. The Otter Sandstone is at beach level. (Author)

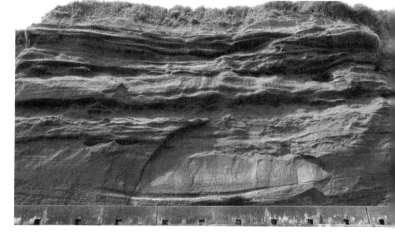

Photograph of a cliff section outcrop of Otter Sandstone at the western end of Sidmouth seafront. It is a member of the Sherwood Sandstone Group, and an analogue of the Sherwood oil reservoir at the Wytch Farm oilfield. (Author)

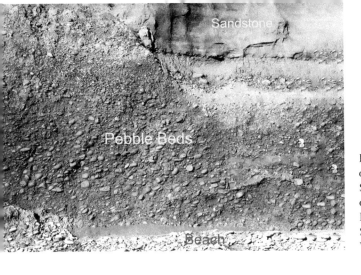

Photograph showing a cliff outcrop of the Budleigh Salterton pebble beds. This is overlain by the Otter Sandstone Formation, an analogue of the Sherwood oil reservoir at the Wytch Farm oilfield. (Author)

brown porous, very permeable sandstones, part pebbly at the base. They were formed in desert conditions during the Triassic geological period, 250 to 200 million years ago, from river floodplain sediments. During the Triassic period, England was subject to desert-like conditions because of its latitude at the time. The pebble beds, sandstones and mudstones of the Triassic period outcrop along the sea cliffs of East Devon from Sidmouth to Exmouth. Here the sandstones are referred to by the name of Otter Sandstones. These outcrops form an important part of the Jurassic Coast World Heritage Site. Useful analogues of the oil-producing Sherwood reservoir at the Wytch Farm oilfield can be found in the cliff sections of the eastern and western ends of the seafront at Sidmouth. The Sherwood oil reservoir has an elongated 'whaleback' like structure capped by the impervious mudstones and siltstones of the Mercia Mudstone Group. At the base of the reservoir the sandstones are pebbly and underlain by the Aylesbeare Mudstone Group.

Frome Clay Limestone

At the Wytch Farm oilfield oil production from the Frome Clay Limestone layer, which lies above the Bridport reservoir, did not start until 1991. By this date production from

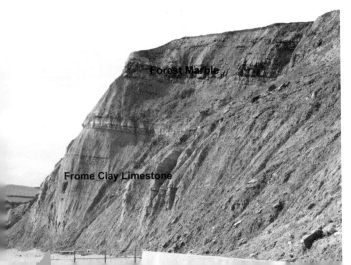

Photograph of the Frome Clay Limestone outcrop at Watton Cliff, West Bay. This is an analogue of the Frome oil reservoir at the Wytch Farm oilfield. (Author)

the Bridport and Sherwood reservoirs had been underway for some time. Therefore, it is somewhat surprising the Frome reservoir had been ignored especially as all Wytch Farm wells pass through it on their way to locations in the Bridport and Sherwood reservoirs.

The Frome Clay Limestone is part of the Great Oolite Series of marine sedimentary rocks laid down during the Middle Jurassic period. Although it does not have the flow characteristics of the Bridport or Sherwood sandstones, it is capable of producing oil consistently at modest rates. The Frome outcrops in a near vertical cliff section at Watton Cliff, West Bay. This provides a useful analogue of the Frome reservoir at the Wytch Farm oilfield.

Source Rock

A typical source rock, usually shale, needs to have a high organic content and be deeply buried for it to be hot enough for the organic content to decompose into oil and gas. During the 1990s a number of studies were undertaken to find the origin of Dorset's oil. These culminated in a special publication of the Geological Society of London in 1998 by two geologists, Underhill and Stonely. In their report they reasoned that oil from all the reservoirs and seeps came from the same source rock. They identified this to be the bottom layers in the Lower Lias Group of shales and clays, laid down during the early part of the Jurassic period. However, they were unable to find an onshore subsurface location deep enough for the generation of oil from this source. Their search led offshore to the south between Purbeck and the Isle of Wight to a subsurface location known as the Portland-Wight Channel Basin. Here, the Lower Lias source rock is buried deep enough for oil generation.

Underhill and Stonely envisaged that during the middle to late Cretaceous period, 100 to 70 million years ago, the oil from the Lower Lias migrated up the Purbeck Fault system. These faults provided the pathways for oil to fill the sandstone reservoirs of Wytch Farm, Wareham and Waddock Cross and the limestone reservoir at Kimmeridge.

An outcrop of the Lower Lias can be found in a cliff section known as the Charmouth Mudstone Formation just to the west of Charmouth. The bottom member of this formation consists of organic rich shales called 'Shales-with-Beef' because of the veins of calcite running through them, like the marbling in beef. This cliff section provides an analogue for the source rock of Dorset's oil.

Photograph of the Charmouth Mudstone outcrop in cliffs to the west of Charmouth. At their base is the Shales-with-Beef member, which is an analogue of the source rock for Dorset's oil. This is buried at depths of thousands of metres subsea in the Portland-Wight Channel Basin offshore. (Author)

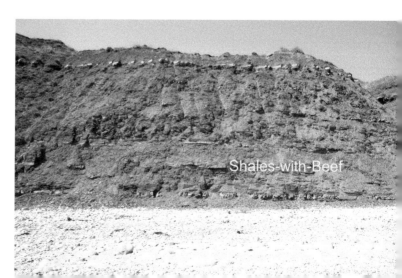

4
Shale Oil and Gas, 1830–1925

It must seem inconceivable to many people visiting Kimmeridge Bay, Dorset, on a sunny day that any form of industry should have been carried on hereabouts. Yet the dark coloured rocks forming the cliff sections in the bay and extending round each headland to the east and west contain layers of organic rich oil shale, which was exploited as a valuable resource in the past.

These shales are part of the Kimmeridge Clay Formation of the Upper Jurassic, which outcrops as cliff sections along this part of Dorset's Jurassic Coast. The shales with the highest organic content are found in the cliff sections to the east of the bay. Here the Kimmeridge Formation dips eastwards towards St Alban's Head. The richest shale is an oil shale known as 'Blackstone' that outcrops in the cliff section above Yellow Ledge and dips to beach level just east of Clavell's Hard. The Blackstone layer is less than a metre thick in most

Photograph showing eastern side of Kimmeridge Bay, the Clavell Tower on the clifftop and the start of the eastern cliff section at Hen Cliff. (Author)

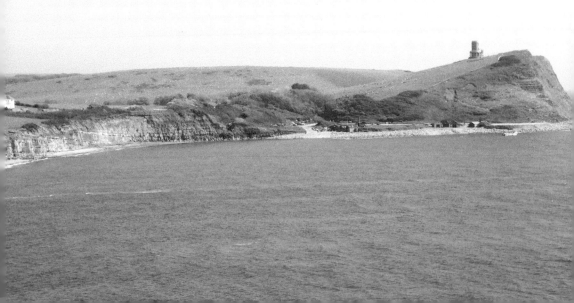

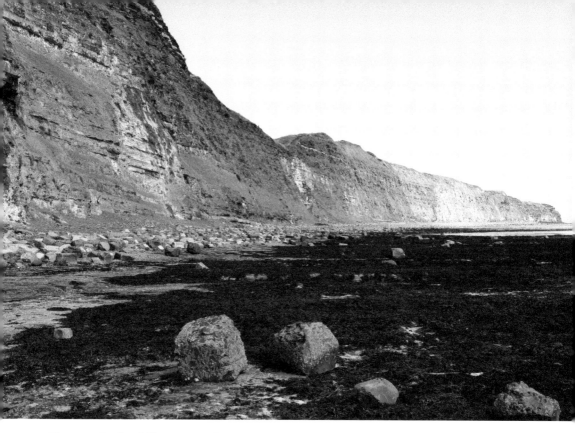

Photograph of a cliff section to the east of Kimmeridge Bay, looking east from Yellow Ledge to promontory at Clavell's Hard. This section contains an outcrop of the Blackstone oil shale layer, which dips down to beach level beyond the distant promontory. (Author)

places. Landward it curves inland below the surface roughly eastward of where the Clavell Tower is today. Early maps of the area sometimes refer to the Blackstone shale as coal.

The shale itself is a fined grained, flaky but hard sedimentary rock that contains organic matter as kerogens tightly bound within its pores and fissures. These kerogens are derived from algal and plant debris trapped in the muddy sediments millions of years ago. When the shale is heated the kerogens release petroleum products in the form of inflammable oils and gases. Hence oil shale will burn in air rather like coal. However, if the shale is heated in the absence of air in a closed vessel, such as a retort, then the oils and gases will be driven off as vapours, which can be condensed as crude oils of various qualities together with natural gas. It was this combustible property that was exploited in the past.

Archaeological evidence strongly indicates that our Romano-British ancestors used the combustible properties of the black rocks found along the coast at Kimmeridge to boil off sea water to produce salt. Much later, during the early seventeenth century, something of an industrial complex began to develop at the eastern end of Kimmeridge Bay. It was here that Sir William Clavell set up works to produce salt, alum and glass using the Blackstone (oil shale) as a source of fuel and chemicals. By the early eighteenth century production had ceased, but the Blackstone, known locally as Kimmeridge Coal, continued to be burned in the hearths of local cottages. There are several accounts at the time of the obnoxious fumes

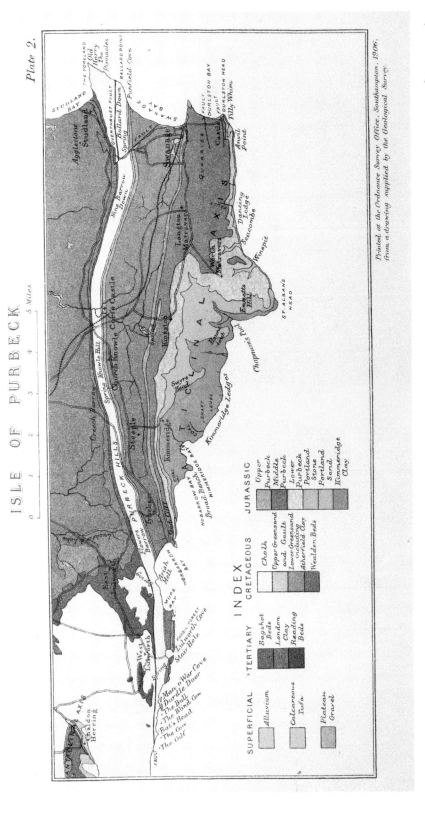

Plate 2.

ISLE OF PURBECK

Printed at the Ordnance Survey Office, Southampton, 1906;
from a drawing supplied by the Geological Survey.

INDEX

SUPERFICIAL
Alluvium
Calcareous Tufa
Plateau Gravel

*TERTIARY
Bagshot Beds
London Clay
Reading Beds

CRETACEOUS
Chalk
Upper Greensand and Gault
Lower Greensand including Atherfield Clay
Wealden Beds

JURASSIC
Upper Purbeck
Middle Purbeck
Lower Purbeck
Portland Stone
Portland Sand
Kimmeridge Clay

Photograph of a geological map dated 1906, showing Kimmeridge Clay Formation containing 'coal', Blackstone oil shale, to the east of Kimmeridge Bay. Positions of a mine shaft on the clifftop and a level (adit) at the cliff face are shown. (Reproduced from a book in the author's possession: Strahan, A., *Geological Model of the Isle of Purbeck* (London: Memoirs of the Geological Survey, HMSO, 1906))

40

Photograph of a sample of oil shale measuring approximately 8 x 6 x 2 cm. Shale is a highly laminated sedimentary rock, composed of compressed mud that breaks easily in the plane of laminations. Oil shales contain partially decomposed organic matter. (Author)

issuing from their chimneys caused by the high sulphur content contained in the shale. It was this sulphur content that was to dog the future exploitation of Kimmeridge shale as a source of oil and gas.

Dorset and Somerset Shale Oil, 1830–1925

There are many publications and internet sources covering the history of the shale oil industry in Britain. This industry extended from Dorset and Somerset in the south to Norfolk in the east and Yorkshire in the north and on to Midlothian and West Lothian in Scotland. The best single source of information is the website of the Museum of the Scottish Shale Oil Industry. The museum highlights not only the history of the Scottish shale oil industry, but covers the history of the industry beyond Scotland, particularly in Dorset and Somerset, which is relevant to this publication. The working of oil shale at Kimmeridge in Dorset has intrigued many geologists and others during the last 190 years or so. Contemporary newspapers often carried articles about Dorset's shale oil business. One newspaper of the day, the *Dorset County Chronicle and Somersetshire Gazette*, became something of a voice piece for the local shale oil industry and today old copies are a useful reference for historians.

It was during the middle of the nineteenth century that developments were taking place in France and Scotland to extract oil and gas from mined organic rich shales by heating them in retorts. It is not surprising that the news of these developments should encourage attempts to exploit the oil shales of Dorset. By around the 1840s considerable quantities of oil shale were being mined in Kimmeridge Bay and from cliffs to the east and transported by road and sea to towns in Dorset such as Wareham, Poole and Weymouth. There are even references to Kimmeridge shale being shipped from Poole to France to be used to produce gas to light the streets of Paris.

The first serious attempt to extract oil from Kimmeridge oil shale appears to have been made by the Bituminous Shale Co., a company set up in Weymouth in 1848 by a group

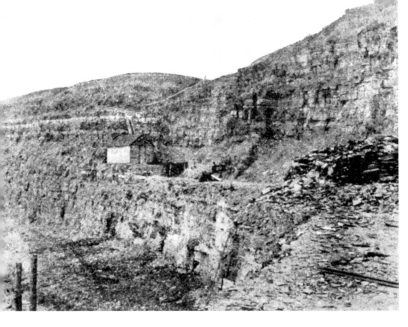

Early photograph of a mine shaft (adit) driven horizontally into the cliff face east of Kimmeridge Bay, probably in the vicinity of Clavell's Hard, to extract the Blackstone oil shale. (Reproduced from a book in the author's possession: Strahan, A., *The Geology of the Isle of Purbeck and Weymouth* (London: Memoirs of the Geological Survey, HMSO, 1898))

of London businesspeople in association with some local people. However, in November of that year the company had asked builders to submit tenders to erect new works at Northport, close to the railway station at Wareham. It is likely they moved into the new premises sometime during the period 1849 to 1850. However, soon after this move the company became embroiled in defending an alleged patent infringement on James Young's patented process for distilling oils from Scottish coal and oil shale. As a result, the company got into financial difficulties and was taken over by the Shale, Manure and Naptha Company who placed an advert for a public offering of its shares in the *Dorset County Chronicle and Somersetshire Gazette* newspaper for 30 September 1852. This was to be the first of a succession of six companies to take over the Wareham shale oil works between the years 1852 and 1868. Their advert is interesting since it also gave a list of products it claimed the company could make from Kimmeridge oil shale. One of these, manure, requires an explanation. In today's agricultural parlance this product would be more accurately described as a fertiliser. This was produced from the spent shale raked out from the retorts after firing.

It appears that the companies who occupied the Wareham site tried different types of retort to process the shale, from the vertical type of Du Buisson to the horizontal type of James Young used in Scotland. Eventually, the Wareham shale oil works were fitted out with 120 horizontal retorts of the James Young pattern. Unfortunately, none of this equipment has survived. However, a scale model of the James Young patented horizontal shale retort is exhibited in the Science Museum, London. The system comprises a 'bench' of five oval-shaped cast-iron retorts, each measuring around 2 feet by 6 feet, connected by pipework and heated by a brick oven. The shale to be processed was broken up into fist-sized pieces and packed into each retort. The oven was fired by burning a mixture of the poorer quality shale and coal. The temperatures in the retorts would need to have reached 350–400 °C (660–750 °F) for the shale to break down and release oil and gas vapours. A simple air-cooled condenser separated out these vapours to produce liquid

Reproduced from *Dorset County Chronicle and Somersetshire Gazette* newspaper for 30 November 1848 showing an advert (ringed red) inviting tenders from builders to erect new premises at Wareham for the Bituminous Shale Company. (© The British Library Board. All rights reserved. With thanks to The British Newspaper Archive (www.britishnewspaperarchive.co.uk))

SHALE MANURE AND NAPTHA COMPANY

Established for the Production of
MANURES, NAPTHA,

ALSO,

JET VARNISH PAINT, MINERAL SPIRIT, MACHINE
OIL, AND ASPHALTUM.

The Business and Interest of the Bituminous Shale Company are
now amalgamated with this Company.

**CAPITAL, £50,000, in 50,000 SHARES of £1 EACH,
To be paid up in full; without further liability.**

COMPLETELY REGISTERED.

**OFFICES, 145, UPPER THAMES STREET, LONDON.
CHEMICAL WORKS, WAREHAM, DORSET.**

1st. The SHALE MANURE, which has all the valuable properties derived from the presence of Charcoal, Phosphate of Lime, and Sulphate of Ammonia, enriched by mineral grease and Chemical wastes. To this branch of their business the Directors attach great importance especially since the encouragement lately held out by the Royal Agricultural Society to the production of cheap and really useful manure: it is one of the most valuable discoveries introduced for many years to the notice of the agricultural world. The attention of the public is invited to the numerous Testimonials received on the subject, as affording the best evidence of its value, even in trials against Guano, for both root and cereal crops.

2nd. SHALE NAPTHA.—A pure Mineral Spirit of great strength and illuminating power, particularly adapted for Burning in Mines, Quarries, and out-door situations in general; for combination with seed and fish oils, thereby increasing their brilliancy and diminishing their cost; also for the Solution of Gums, India Rubber, Gutta Percha, &c. Contracts can be immediately entered into for the whole make of this article.

3rd. A JET VARNISH PAINT, of unrivalled brilliancy, that will stand any degree of heat without shrinking or melting: this can be recommended with great confidence to Railway Companies, Shipbuilders, Engineers, Founders, Agricultural Implement Makers, Packing Paper Makers, and others. Its peculiar properties are –drying rapidly, and covering a much greater surface than any other paint; preventing rust on iron, and the rot in wood, or filling up the pores with a solid material; it is not affected by acids, and one coat is sufficient to give a brilliant enamelled surface. It has been tested by the Select Committee of Her Majesty's Board of Ordnance at Woolwich, and has received their unqualified approbation and patronage (see Testimonials); also by numerous Railway Companies and private establishments.

4th. MACHINE OIL.—This is extensively used in many Mines, Factories, &c., possesses great lubricating powers due to the presence of Paraffine. (See Testimonials.)

CONTRACTS have been offered to the Company for more

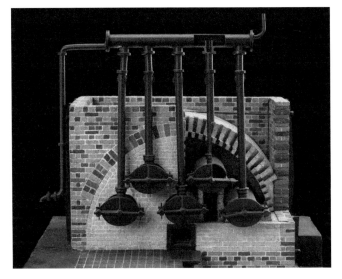

Photograph of a scale model of James Young's patented horizontal oil shale retort. Retorts like this were used in Dorset's shale oil works at Wareham and Sandford. (Science and Society Picture Library)

crude oil and gas. It seems a separate distillation process was used to convert the crude oil into various hydrocarbon products such as naphtha, paraffin, lubricating oil, waxes and asphalt. The gas was used to light the works. After firing, the spent shale, still hot, was raked out of the retorts into tubs of water. Here, the inorganic salts and sulphur contained within the spent shale combined to produce chemicals such as ammonium sulphate, a useful agricultural fertiliser.

The oil works at Wareham must have been a hot, smelly place, judging by a complaint recorded in the *Dorset County Chronicle and Somersetshire Gazette* of 31 August 1854. The article reported a strong complaint from the town, made to the Board of Guardians, of the 'very offensive and sickly smell' coming from the works. The complainants asked for the Board of Health to be informed and be asked of their views.

Despite complaints, infringements of patents and an almost constant turnover of owners the Wareham shale oil works continued in uninterrupted business for the next nine years. In 1863 all this was to change. A short article in the *Dorset County Chronicle and Somersetshire Gazette* of 30 April 1863 reported a disastrous fire in the still room of the works, the second in two weeks. At this date the works were owned by the Wareham Oil and Candle Co. Ltd. The works never recovered from the fire and the company went into voluntary liquidation in April 1864. The premises were put up for let or sale in 1868. The fate of the equipment is unknown.

The next attempt at processing Kimmeridge oil shale does not appear until 1886 when a company by the name of Kimmeridge Oil and Carbon Co. Ltd took over some works at Sandford on the outskirts of Wareham. These works originally produced bricks, pottery and china and it appears they converted some of the works to produce oil from shale, which the company mined in and around Kimmeridge Bay. It is not known how the company equipped the works, but they might have used some or all of the equipment from the Wareham works. According to the Museum of the Scottish Shale Oil Industry, Sandford produced around 50 tons of oil per year and enough gas to heat and light the works. By 1890 the works had closed leaving no records of the equipment installed or the technology employed.

By the beginning of the twentieth century the shale oil industry in Dorset was in decline and had all but disappeared by the 1920s. The companies, which had such high hopes of establishing an oil industry based on Kimmeridge oil shale, had either been dissolved voluntarily or had gone bankrupt. However, about this time there was one place in the Wessex Basin where hopes ran high of establishing a shale oil industry. This was at Kilve on the north-west Somerset coast in Bridgwater Bay, Bristol Channel. Here, the shales are part of the Lower Jurassic, Blue Lias Formation, although they are similar in appearance to the shales of the Kimmeridge Clay Formation.

It was the cliffs at Kilve Pill in Somerset that came to the attention of one Dr William Forbes-Leslie. Undaunted by earlier attempts at establishing a shale oil works in Norfolk, Forbes-Leslie pressed ahead with promoting a similar scheme based on the shale discoveries at Kilve Pill. During the years 1923–24 operations were based here, culminating in a vertical iron retort of the Du Buisson type, housed in a brick enclosure designed as an oven to heat the shale to drive off oils and gases. However, Forbes-Leslie failed to overcome the problem of the obnoxious smell of the shale oil arising from the high sulphur content of the shale itself, making the oil products he produced unsaleable. He was unable to

WAREHAM.

A SECOND FIRE, attended with more disastrous results, took place at the Parafine works at Northport, on Wednesday evening last. This, as well as the former fire, about a fortnight before, originated from incautiously over-heating the still, the pressure being so great as to blow off the heavy head, and allow the atmospheric air to come in contact with the highly-heated petroleum, which immediately fired, and a terrific body of flame and smoke instantaneously shot up to a great height, attracting crowds of lookers-on from all parts. There were many thousand gallons of oil and combustible matter on the premises, and much anxiety was manifested. Every exertion was made by the hands employed on the works, and under the skilful guidance of Mr. Southby, the fire was confined to the still-room. From the commencement of these works, first as the Bituminous Shale Company, in the year 1848, to the present time, they have, like a barometer, been constantly rising and falling; at one time holding out every prospect of long years of constant employment and a not-to-be-estimated amount of profit to the fortunate shareholders, and again sinking, if possible, below zero. The present undertaking has been a decided success; the parafine operations have been carried on with much spirit, producing candles to a vast extent, and of a quality inferior to no other establishment. We trust these mishaps will soon be remedied, and that the company will, phœnix like, spring from its ashes with renewed life and spirit.

Left: Reproduction of a report of a fire at the Wareham shale oil works in the *Dorset County Chronicle and Somersetshire Gazette* newspaper for 30 April 1863. (© The British Library Board. All rights reserved. With thanks to The British Newspaper Archive (www.britishnewspaperarchive. co.uk))

Below: Photograph of cliff section at Kilve Pill, Bridgwater Bay, Somerset, showing an outcrop of Blue Lias oil shale. Inset shows a close-up of a layer of shale. (Author)

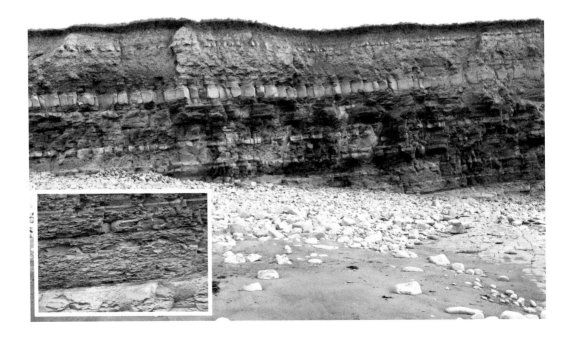

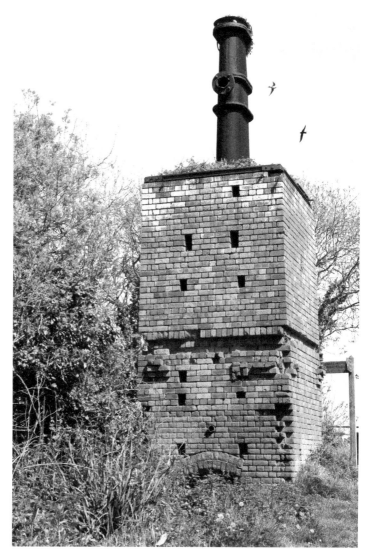

Photograph of a vertical retort of the Du Buisson type and brick furnace, used in the 1920s for extracting oil from local shale. It is in the beach car park at Kilve Pill, Bridgwater Bay. Shale was loaded from the top and spent shale and the furnace fire accessed through the arched doorway at the bottom. (Author)

raise sufficient funds for further research and development and so by 1925 the project had been abandoned. However, the project left as its legacy the iron retort and most of its surrounding brickwork, which stands today as a Grade II listed building in what is now the beach car park at Kilve Pill. This is probably the only piece of equipment remaining from the nascent shale oil industry of southern England.

Oil Yields from Shale

Various authors, past and present, have quoted the yields of oil derived from processing oil shale in the retorts used at shale oil works in Dorset and Somerset during the nineteenth century. The numbers quoted show that a considerable tonnage of shale would have been

needed to produce even a modest volume of shale oil. Unfortunately, there are only scant references to the daily volumes of shale oil produced by the Dorset shale works. A figure of 50 tons of oil per month for the Wareham oil works and a figure of 50 tons of oil per year for the Sandford oil works are often quoted. These figures give an average daily oil rate of around eleven barrels per day for the Wareham works and just around one barrel per day for the Sandford works. It is unlikely operations were continuous at either site so these production figures should be regarded as rough estimates averaged over the course of a year. It is interesting to note these oil rates are much lower than those from typical British onshore conventional oil wells, which usually achieve early production rates of several hundred barrels per day.

By 1925 the production of shale oil in Dorset and Somerset had ceased. It seems reasonable to conclude that the shale oil industry in southern England could never have successfully scaled up its early attempts at producing oil. Too many things stood in the way of making progress, not least of which was the lack of funding. Patent infringements of James Young's Scottish shale oil technology sapped time and money out of the businesses trying to set up similar technology in Dorset. The high sulphur content of Kimmeridge shale did not help matters, because it tainted some of the products intended for domestic use, such as lamp oil, making them unmarketable. This latter point is best summed up in an article by Mansel-Pleydell. In referring to the production of oil from Kimmeridge shale he wrote, 'the production of valuable oils and other ingredients must remain undeveloped until a system of deodorization has been discovered, and until then every attempt to bring the shale into a marketable condition must as hitherto end in disappointment...' By comparison the Scottish shale oil industry burgeoned from its beginnings to become a substantial oil producer well into the twentieth century. It produced 6,000 barrels per day at its peak, but ceased production during the early 1960s when it could not compete economically with oil produced from oil reservoirs under the North Sea.

Reference/Location	Quoted Yield of Shale Oil	Barrels Oil* per Ton of Shale
Museum of Scottish Shale Oil Industry (2018), Midlothian	80 gallons/ton	2.3
Prudden (2004), Somerset	156 litres/cubic metre	0.8
Strahan (1906), Dorset	60 gallons/ton	1.7
Mansel-Pleydell (1894), Dorset	50 – 67 gallons/ton	1.4 – 1.9

*35 gallons per barrel

Table of yields of shale oil from retort processing. A typical yield is one to two barrels per ton of shale. A typical UK onshore oil well might produce 300 barrels per day at start-up. To achieve this oil rate from shale would require processing 150 to 300 tons per day – inefficient by comparison. (Author)

5

Conventional Oil Exploration, 1936–2019

The Wessex Basin, with Dorset at its core, has all the elements for oil exploration. It has oil seeps, oil shales, surface features of land that indicate subsurface oil traps and cliff section outcrops of potential oil-bearing rock lying deep underground. Therefore, it is not surprising that Dorset has attracted a lot of oil exploration over the past eighty years or so. In that time there have been sixty wells drilled purely to find oil or gas. These are exploration wells, usually drilled vertically at some prospective location defined by geological data.

Exploration wells are used for much more than checking the presence of hydrocarbons. For example, rock cuttings from the drilling process are routinely examined for oil, but they can also be used to identify the type of rock being drilled. In this way the subsurface strata through which the well is passing can be established, thereby confirming, or otherwise, the geological picture of the location being drilled. If oil is discovered in sufficient quantities, then the exploration well can be reconfigured to carry out short-term flow tests. Such tests bring oil to the surface, enabling its properties to be measured and future long-term rates of production estimated. Pressures measured in the well during these tests are used to estimate the size of the discovery. Any water accompanying the oil will also be measured and analysed. It is parameters such as these that determine how much oil is in place, whether it is light or heavy, whether it will flow easily and at what rates? The answers will determine the long-term success or failure of the discovery.

The first exploration well in Dorset was drilled in 1936 and, at the time of writing, the last was drilled in 2002. Exploration wells have been drilled all over the county, from the north near Shaftesbury to the west near the Devon border and to the east close to the border with Hampshire. However, it is in the south of Dorset, mainly to the east of Weymouth, that most exploration drilling has occurred and been most successful. Here, four oilfields were discovered, developed and put on production during the years 1959 to 1978. These fields, named Kimmeridge, Waddock Cross, Wareham and Wytch Farm, are still in production today.

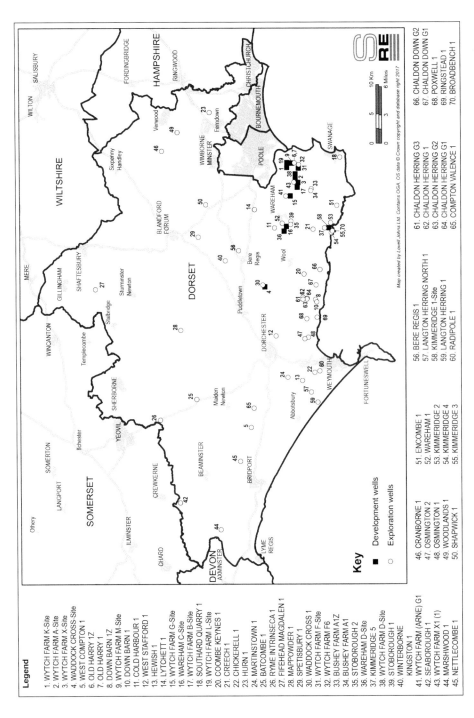

Legend

1. WYTCH FARM K-Site
2. WYTCH FARM A-Site
3. WYTCH FARM X-Site
4. WADDOCK CROSS-Site
5. WEST COMPTON 1
6. OLD HARRY 1Z
7. OLD HARRY 1
8. DOWN BARN 1Z
9. WYTCH FARM M-Site
10. DOWN BARN 1
11. COLD HARBOUR 1
12. WEST STAFFORD 1
13. HEWISH 1
14. LYTCHETT 1
15. WYTCH FARM G-Site
16. WAREHAM C-Site
17. WYTCH FARM B-Site
18. SOUTHARD QUARRY 1
19. WYTCH FARM L-Site
20. COOMBE KEYNES 1
21. CREECH 1
22. CHICKERELL 1
23. HURN 1
24. MARTINSTOWN 1
25. BATCOMBE 1
26. RYME INTRINSECA 1
27. FIFEHEAD MAGDALEN 1
28. MAPPOWDER 1
29. SPETISBURY 1
30. WADDOCK CROSS 1
31. WYTCH FARM F-Site
32. WYTCH FARM F6
33. BUSHEY FARM A1Z
34. BUSHEY FARM A1
35. STOBOROUGH 2
36. WAREHAM D-Site
37. KIMMERIDGE 5
38. WYTCH FARM D-Site
39. STOBOROUGH 1
40. WINTERBORNE KINGSTON 1
41. WYTCH FARM (ARNE) G1
42. SEABOROUGH 1
43. WYTCH FARM X1 (1)
44. MARSHWOOD 1
45. NETTLECOMBE 1

46. CRANBORNE 1
47. OSMINGTON 2
48. OSMINGTON 1
49. MARSHWOOD 1
50. NETTLECOMBE 1

51. ENCOMBE 1
52. WAREHAM 1
53. KIMMERIDGE 2
54. KIMMERIDGE 4
55. KIMMERIDGE 3

56. BERE REGIS 1
57. LANGTON HERRING NORTH 1
58. KIMMERIDGE 1-Site
59. LANGTON HERRING 1
60. RADIPOLE 1

61. CHALDON DOWN G3
62. CHALDON HERRING 1
63. CHALDON HERRING G2
64. CHALDON HERRING G1
65. COMPTON VALENCE 1

66. CHALDON DOWN G2
67. CHALDON DOWN G1
68. POXWELL 1
69. RINGSTEAD 1
70. BROADBENCH 1

Key

■ Development wells

○ Exploration wells

Map created by Lovell Johns Ltd. Contains OGA data. OS data © Crown copyright and database right 2017

Map showing the location of all the exploration wells drilled in Dorset from 1936 to 2019. Oilfield development sites with one or more wells are also shown. Sometimes an exploration well is converted to a development well for oil production. (Prepared by Lovell Johns Ltd. Contains OGA data, OS data © Crown Copyright and database right 2017)

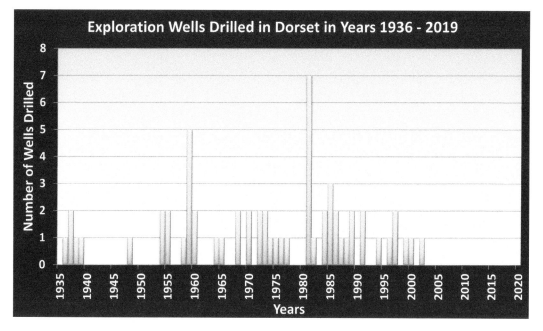

Chart showing a timeline of exploration wells drilled during the period from 1936 to the end of 2019. (Author, contains information from the Oil and Gas Authority (OGA))

The D'Arcy Oil Exploration Company (later to become BP) drilled the first Dorset exploration well from the clifftop at Kimmeridge. This well was called Broadbench 1, after the name of the nearby promontory. It was a vertical well drilled to a total depth of 278.3 metres (913 feet). It found only traces of oil in an Upper Jurassic limestone rock formation called the Corallian. No oil flowed to the surface.

Photograph showing the clifftop at the western end of Kimmeridge Bay, the site of the first Dorset exploration well, Broadbench 1, in 1936 and the site of the Kimmeridge 1 oil discovery well in 1959. (Author)

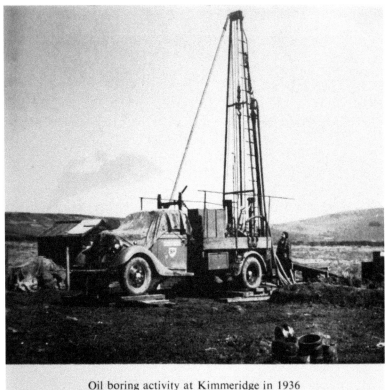

Oil boring activity at Kimmeridge in 1936

Photograph of a mobile drilling rig in use on the clifftop at Kimmeridge in 1936. This could be an image of the first oil well to be drilled in Dorset. (Photo reproduced here courtesy of the *Dorset Year Book* 1959 edition)

During the years leading up to the Second World War, the same company drilled a further three vertical exploration wells named Ringstead 1, Poxwell 1 and Chaldon Down G1. It is usual for onshore wells in the UK to be named after a nearby village or farm. All these wells were relatively shallow at less than 375 metres (1,230 feet) and were either dry or showed only minor oil traces. None of the wells produced oil to the surface.

After the war, exploration drilling resumed and something of a record was made. The D'Arcy Oil Exploration Company had just started drilling the Chaldon G2 well when war was declared in 1939. As a result the drilling rig was demobilised and the well capped at the surface. In this state the well was quite safe and said to be suspended. After the end of the war, drilling the well resumed and it was completed in 1946, seven years following its suspension. At seven years this has to be the longest suspension of a well drilling. Normally, a well drilling might be suspended for hours, days or perhaps a week while waiting for repairs, equipment or weather.

Exploration drilling eventually got going again from around 1954. The D'Arcy Oil Exploration Company drilled four conventional, vertical wells near the village of Chaldon Herring during the years 1954 and 1955. The Chaldon Herring 1 well was drilled to a total vertical depth of 487.4 metres (1,599 feet) subsea but failed to find any mobile oil. Despite its depth the well failed to intersect all the anticipated geological strata. In 1955 the company began drilling the Chaldon G3 vertical well using a mobile rig. Having reached a depth of 304.8 metres (1,000 feet) the well was suspended having failed to reach the

Photograph of a drilling rig used to drill the Poxwell 1 well in 1937. Poxwell shows as 'Poxwell' without the word circus on Ordnance Survey maps at the time and later. (Reproduced from a book in the current author's possession: Arkell, W. J., *Geology of the Country Around Weymouth, Swanage, Corfe and Lulworth* (London: HMSO, 1947))

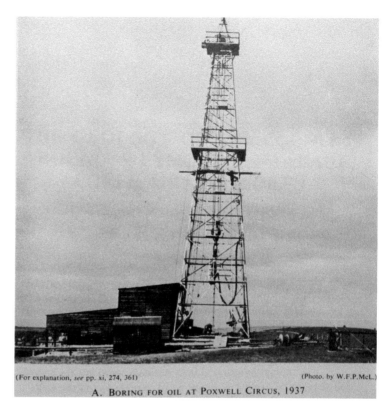

(For explanation, *see* pp. xi, 274, 361) (Photo. by W.F.P.McL.)

A. Boring for oil at Poxwell Circus, 1937

target Bencliff Grit, part of the Corallian rock formation. A Bencliff Grit outcrop east of Osmington Mills is oil saturated and so at the time it was thought reasonable to expect oil to be trapped in this layer of rock at depth inland. A more powerful drilling rig was brought in to push the well deeper. Despite reaching a total depth of 495.3 metres (1,625 feet) the well failed to find the target rock layer and failed to find any oil shows. The other two Chaldon Herring wells also proved dry.

One can sense the feeling of frustration failing to find oil since further exploration drilling did not take place until 1958. During the period from the beginning of 1958 to the end 1960 eight conventional, vertical exploration wells were drilled. By this time the operating company had changed its name from D'Arcy Oil Exploration Company to BP Exploration Company. Many of the wells drilled during this period were deeper than those drilled previously. As a result the wells penetrated the rock strata of the older Middle and Lower Jurassic periods, which outcrop samples had shown could make them oil bearing at depth.

Three wells, one at Radipole and two at Langton Herring, were drilled on a geological structure known as the Weymouth Anticline. Each well passed through 200 feet or more of a thick layer of Bridport Sandstone, which outcrops as cliff sections from Burton Bradstock to West Bay, Bridport. This sandstone was found to be oil bearing in the Radipole 1 and Langton Herring North 1 wells at depths of around 250 metres (820 feet) subsea. However, oil could not be persuaded to flow to surface at either well during testing. The only oil to reach surface bled from cores cut during the drilling and brought up to be examined.

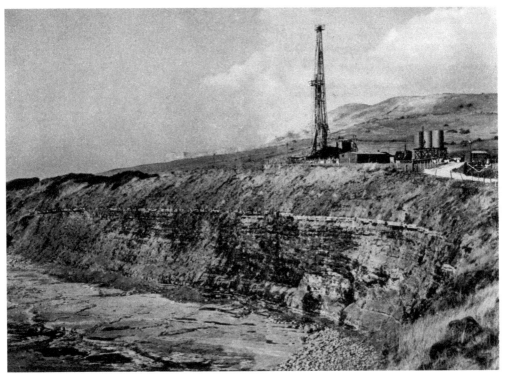

OIL IN DORSET: The drilling rig of the Broadbench No. I Well stands on the edge of the cliffs near Kimmeridge. Oil has been found there by the B.P. Exploration Company at about 1,800 ft. in limestone. Drilling will continue, probably to 4,000 ft. Much further work is required before the drilling can prove commercial possibilities.

Photograph showing the drilling of the Broadbench 1 well, later renamed Kimmeridge 1 exploration well, on the clifftop of Kimmeridge Bay. (Unattributed photograph in the *Sphere* magazine, 11 April 1959, © Illustrated London News Ltd/Mary Evans)

It could be said that at last an oil discovery had been made, although at deeper levels and in a different type of rock formation than anticipated by the earlier explorations.

Encouraged by this success, BP returned to the clifftop at Kimmeridge in 1959 to drill the Kimmeridge 1 conventional, vertical exploration well, which was completed in April of that year. It reached a total depth of 528.2 metres (1,733 feet) subsea and encountered a full section of fissured, Upper Cornbrash Limestone some 50 feet thick. The Upper Cornbrash outcrops at East Fleet. Core recovered to surface was found to be heavily impregnated with greenish tinged light oil that flowed freely from the fissures. On test, oil was produced to surface at a high rate with no water. Subsequently, the well was converted to a production well. BP had made not only an oil discovery, but had discovered an oil reservoir that is still producing some sixty years later.

Following the successful Kimmeridge 1 well, BP drilled a further three vertical exploration wells at Kimmeridge from October 1959 to September 1960. In chronological order the wells were Kimmeridge 3, Kimmeridge 4 and last but not forgotten Kimmeridge 2. Apparently, the Kimmeridge 4 well did not go very deep and was presumably plugged and abandoned and the drill site restored. The Kimmeridge 2

and Kimmeridge 3 wells were drilled equidistant 0.7 kilometres (0.4 miles) from the Kimmeridge 1 well. Both wells intersected the Cornbrash Limestone Formation at slightly different depths below 525 metres (1,722 feet). However, the Kimmcridge 3 well was drilled deeper and intersected a layer of Bridport Sandstone. Only the Cornbrash proved oil bearing and only in the natural fissures as shown in rock cores brought to the surface. The Bridport Sandstone contained only water. When the Kimmeridge 3 well was flow tested it produced some oil with a lot of water. In this respect these two wells behaved very differently to the Kimmeridge 1 well and in a sense marked out the limited extent of the Kimmeridge reservoir itself.

In 1962 BP carried out reflection seismic surveys to the west of the town of Wareham. Analysis of the resulting seismic sections revealed subsurface geological structures that could hold oil in the limestones and sandstones of the Middle and Lower Jurassic. A conventional, vertical exploration well was drilled in 1964. This well discovered oil in the Cornbrash and Forest Marble limestones and in the deeper Bridport Sandstone. This was followed by an appraisal well, Wareham 2, drilled in 1965. This well confirmed mobile oil in layers of the Bridport Sandstone below 865.2 metres (2,839 feet) subsea. On test, both wells produced oil at modest but sustainable rates. BP had discovered another oilfield. Unsurprisingly, they called it Wareham.

The decade from 1968 to 1978 saw twelve conventional exploration wells drilled at various locations from east to west of the county. There are a number of reasons for this upsurge in exploration drilling. The main one was the realisation that the Bridport Sand Formation could contain oil-filled geological structures identifiable from seismic surveys. Oil companies now had an exploration target. Drilling rigs had also become more powerful, enabling wells to reach these structures with ease. They were now being operated by specialist contractors, which meant that smaller oil companies, other than the oil majors, could drill wells without owning the rigs to drill them. All this activity inevitability led to concerns about risks to health and safety and damage to the environment. This meant that operators holding exploration licences had to comply with guidelines and regulations laid down by central and local government bodies. In practical terms an exploration drill site had to be carefully planned to mitigate against the perceived risks. The same is true today, perhaps even more so.

The decade 1968 to 1978 saw some important discoveries. The first of these was made by British Gas in 1973 when it drilled its first exploration well in Dorset at Wytch Farm. It had previously identified a potential subsurface oil-bearing structure from analysis of recently acquired seismic surveys of the area. The conventional, vertical exploration well Wytch Farm X1(1) discovered an oil reservoir in the Bridport Sand Formation at depths below 883 metres (2,897 feet) subsea. On test, the well produced oil and water to surface. In 1975 British Gas drilled a conventional exploration well at Arne on the fringes of Poole Harbour. This was a deviated well with a horizontal step out of about half a kilometre. The well intersected the Bridport Sandstone at a depth of 921 metres (3,021 feet) subsea. When tested, it too produced oil to surface at a rate of around fifty barrels per day. At the time it was thought to be a separate oil reservoir, but now is known to be part of the Wytch Farm oilfield.

When BP drilled the Wareham 1 exploration well they had deepened it to penetrate the rock formations of the Triassic period at depths below 1,600 metres, far below the Bridport Sandstone. They found a thick sandstone layer, later identified as part of the Sherwood

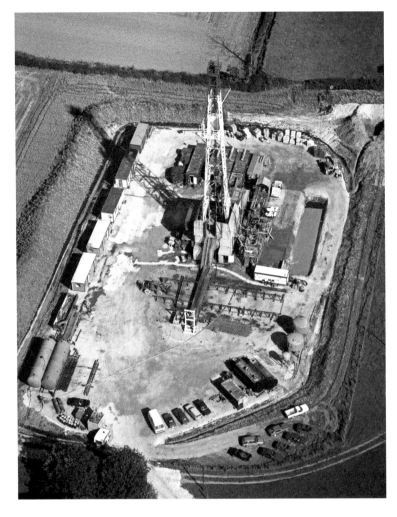

Photograph showing a typical UK onshore, conventional, exploration drill site of the 1980s. The hardstanding is contained within a bund to contain leaks/spillages from entering neighbouring land. (A.P.S. (UK)/Alamy Stock Photo)

Sandstone Group. Unfortunately, it was water bearing without any trace of oil. During the winter of 1977/78 British Gas, now developing the Wytch Farm oilfield, decided to target the underlying Sherwood sandstones by drilling an appraisal well Wytch Farm D2. This was drilled as a deviated well that intersected the Sherwood at 1,558.7 metres (5,114 feet) subsea, nearly a mile below the surface. Flow tests proved oil in sufficient quantities to warrant development as a separate reservoir. British Gas had discovered the largest onshore oil reservoir in Western Europe, although they did not realise it at the time.

It was not only oil companies that drilled exploration wells in Dorset during the period 1968 to 1978. The Petroleum Engineering Division of the UK Department of Energy drilled a vertical exploration well at Winterborne Kingston during winter 1976/77. Although it failed to find oil it was extensively cored during drilling. As a result, this well has provided a nearly complete stratigraphic column of the sedimentary rocks of the Wessex Basin from the Upper Cretaceous period (70 million years ago) to the Middle-Upper Permian period (265 million years ago). It reached a total depth of 2,978.2 metres (9,771 feet) subsea, nearly 2 miles deep, which makes the well the deepest exploration well in Dorset. The depth of

Chart showing the true vertical total depths of the exploration wells drilled in Dorset from 1936. The depths are shown in feet and metres and are relative to a datum of mean sea level, abbreviated to subsea. (Author, contains information from the Oil and Gas Authority (OGA))

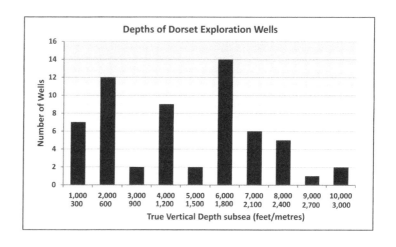

exploration wells in Dorset ranges from 300 metres (984 feet) subsea to nearly 3,000 metres (9,842 feet) subsea. The earliest wells tended to be at the shallower end of the depth range and the latest wells at the deeper end of the range since they were targeting potential Sherwood Sandstone oil reservoirs at depths below 1,600 metres subsea.

During the next two decades from 1980 to 2000 twenty-seven exploration wells were drilled across the county of Dorset. This represents nearly half of all the exploration wells ever drilled in the county. Despite this activity only one additional oilfield was discovered. Most of the other exploration wells were either dry or showed only minor oil shows. In 1982, Gas Council Exploration, a subsidiary of British Gas, drilled a vertical exploration well at Waddock Cross. The well penetrated both the Bridport and Sherwood sandstones. The Sherwood produced only water to surface, but the Bridport, at a depth of 611.4 metres (2,006 feet) subsea, produced oil and water to surface. On test, the oil rate was a modest thirty barrels per day. Much later another oil company, Egdon Resources plc, took up the challenge of developing the Waddock Cross oilfield.

To date, the last exploration well in Dorset was drilled at West Compton in 2002 by a company called Bow Valley Energy Ltd. It was a conventional well, but instead of being vertical it was drilled as a deviated well with a horizontal step out of just over 1 kilometre (0.6 miles). It reached a true vertical depth of 1,259.8 metres (4,133 feet) subsea in the Sherwood Sandstone having passed through the shallower limestones of the Cornbrash and the sandstones of the Bridport. There were no oil shows in any of these layers.

The history of oil exploration in Dorset has spanned over eighty years and during this time oilfield technology has developed. Seismic surveying has gone from employing a single shot seismic source and a mechanical seismograph to record the subsurface reflections to mobile vibrator trucks generating the seismic source and long lines of geophones to detect the reflections from many subsurface rock layers. Add in the impact of digital technology to data recording, collection and analysis then today's seismic surveying is quick, unobtrusive and gives an accurate picture of the many rock layers beneath the ground to aid oil exploration. During the same period onshore rotary drilling rigs have been built with more powerful rotary drives and taller derricks to accommodate longer stands of drill pipe than the earlier rigs used for exploration.

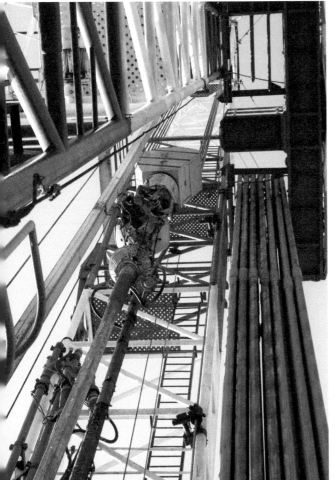

Above: Photograph of a vibrator truck used to generate a source of low-frequency sound waves for seismic surveying of subsurface rock layers. The plate underneath the vehicle is placed in contact with the ground and vibrated. (Author, photo courtesy of GeofizykaTorun)

Left: Photograph of view to top of derrick of a modern onshore drilling rig. On the right is a vertical stand of drill pipe, two 30-foot sections pre-connected for efficiency, ready for connection to drill string. (Greenshoots Communications/Alamy Stock Photo)

6

Kimmeridge Oilfield, 1959–2019

The Kimmeridge oilfield, with its single producing well, is probably the most visited oilfield in the country since it is situated in a major tourist spot on the Dorset coast. Its history goes back to 1936.

The first well at Kimmeridge was the Broadbench 1 (B1) well drilled by the D'Arcy Exploration Company during late 1936 to August 1937. It was located at the landward end of the Broadbench

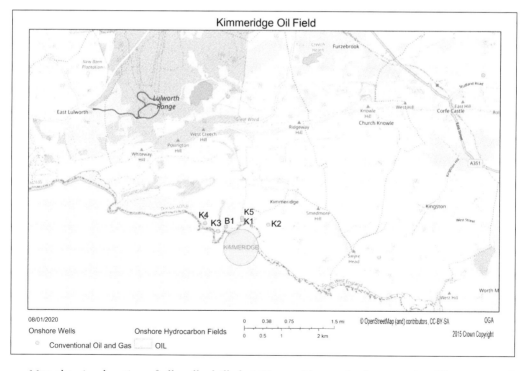

Map showing location of all wells drilled at Kimmeridge, author's annotation. The extent and location of the Kimmeridge oilfield, as shown on the map, are notional. The only visible well site is Kimmeridge 1 (K1). All others have been restored. (© OpenStreetMap and contributors, CC-BY-SA, Oil and Gas Authority OGA 2015 Crown Copyright)

promontory, at the western end of Kimmeridge Bay. The well reached a total vertical depth of 278.3 metres (913 feet) subsea. Traces of light oil were discovered at the relatively shallow depth of 252 metres (827 feet), but were not tested. The well was later plugged and abandoned.

Some twenty-two years later British Petroleum Exploration Company (BP) chose a site on the clifftop at Kimmeridge for a second exploration well. Unfortunately, this well site fell just inside the danger zone of the army's newly acquired tank firing range occupying the high ground to the west of Kimmeridge Bay. Not surprisingly, the well site was moved to just outside the danger zone. Drilling took place during February to March 1959 and was originally called Broadbench 2, but later renamed Kimmeridge 1 to avoid confusion with the name of the earlier well. The drilling of this well featured in the prestigious weekly illustrated newspapers of the day. One such paper, *The Illustrated London News*, published an unattributed night-time photograph of the drilling rig, together with a lengthy caption, in its edition of 11 April 1959. Drilling operations at well sites went on twenty-four hours per day then, as they do nowadays. On the same day, the sister weekly illustrated newspaper, *The Sphere*, published an unattributed day time photograph of the same rig together with a similar caption. This image is shown again, in this chapter, for completeness. The 1,800 feet well depth given in the editorial captions probably refers to the driller's measure of well depth, which uses the rig's rotary table as a datum rather than sea level as used by reservoir engineers and geologists.

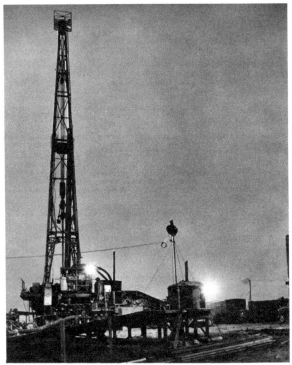

A "SHOW" OF OIL FOUND IN DORSET: A NIGHT PHOTOGRAPH OF THE 80-FT.-HIGH
B.P. EXPLORATION COMPANY'S DRILLING RIG NEAR KIMMERIDGE.
It was announced recently that a show of oil had been encountered at a depth of about 1800 ft. in limestone in the Broadbench No. 1 well being drilled near Kimmeridge, Dorset, by the British Petroleum Exploration Company. Drilling was expected to continue to a depth of about 4000 ft.

An unattributed photograph published in the *Illustrated London News* of 11 April 1959. It shows a night view of drilling the Kimmeridge 1 well on the clifftop at Kimmeridge Bay. Their caption names the well Broadbench 1, which confusingly was the name used for an earlier well drilled in 1936. (Illustrated London News Ltd/Mary Evans)

Fortunately, the new well found oil in the naturally fissured Cornbrash Limestone Formation at a vertical depth of around 512 metres (1,680 feet) subsea. The well itself reached a total true vertical depth of 528.2 metres (1,733 feet) subsea. A core, cut during drilling, oozed oil from veins (natural fissures) within the core on bringing it to the surface. An initial production test revealed an oil rate of 30 bpd, but flowed at higher rates after the well was cleaned of drilling debris. Following these tests the Kimmeridge 1 well was completed as an oil producer and as such has been in continuous production ever since. Except for short periods of downtime for maintenance, this well has produced oil for some sixty years. At first, the well flowed oil naturally until 1964 when a beam pump, 'nodding donkey', was installed as a means of providing some artificial lift. This helped to increase the oil rate, which peaked at nearly 500 bpd in 1972. The oil production profile for the Kimmeridge oilfield to December 2019 shows an increasing rate over the first ten years or so, followed by an initial steep decline from the peak of production to a more gradual decline from around 1986.

In an attempt to gain a better understanding of the Kimmeridge oil discovery, BP drilled a further three wells during the period from the beginning of October 1959 to early

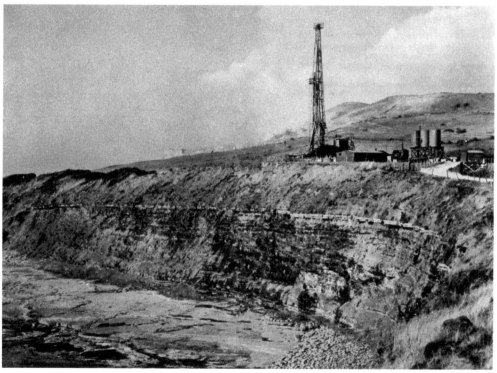

OIL IN DORSET: The drilling rig of the Broadbench No. I Well stands on the edge of the cliffs near Kimmeridge. Oil has been found there by the B.P. Exploration Company at about 1,800 ft. in limestone. Drilling will continue, probably to 4,000 ft. Much further work is required before the drilling can prove commercial possibilities.

An unattributed photograph published in *The Sphere* weekly newspaper of 11 April 1959. It shows a daytime view of drilling the Kimmeridge 1 well on the clifftop at Kimmeridge Bay. There is no record of the drilling continuing to 4,000 feet, as mentioned in the caption to the original photograph. (Illustrated London News Ltd/Mary Evans)

Photograph of the iconic 'nodding donkey' beam pump at the Kimmeridge 1 well site on the clifftop at Kimmeridge. This oil well has been producing oil for sixty years. (Author)

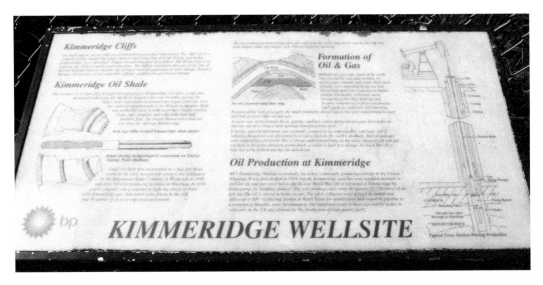

Photograph of the information board outside the perimeter fence of the Kimmeridge 1 well site on the clifftop at Kimmeridge. The operator is now Perenco UK Ltd. (Author)

September 1960. These wells were labelled Kimmeridge 2, 3 and 4, but bizarrely were not drilled in numerical order. The Kimmeridge 3 well was the first of the trio to be drilled in October 1959 to be followed, quite reasonably, by the Kimmeridge 4 well, in May 1960. The Kimmeridge 2 well was drilled after both of these wells in July 1960. The drilling and results from each of these wells is described, in detail, in a Geological Society report.

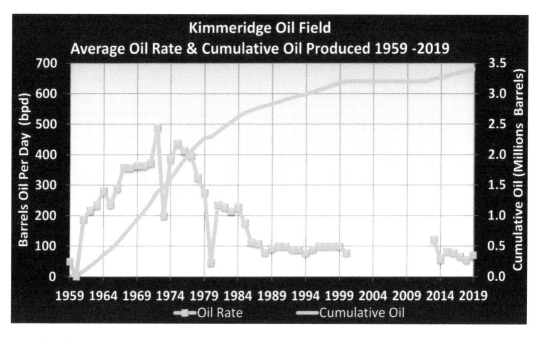

Timeline of oil rate and cumulative oil produced from the Kimmeridge oilfield over a period of sixty years. The rates from 2000 to 2012 are not available. (Author, contains information from the Oil and Gas Authority (OGA))

The Kimmeridge 3 vertical well was drilled from a surface location just 720 metres (2,362 feet), less than half a mile, from the successful and oil-producing Kimmeridge 1 well. The well penetrated the Cornbrash Limestone reservoir and was drilled deeper into the Bridport Sands, which were found to be unproductive in oil, but produced plenty of water. An oil water contact (OWC) was found at a vertical depth of 535.5 metres (1,757 feet) subsea and below the Cornbrash oil reservoir. The Kimmeridge 3 well was subsequently plugged back and completed as an oil producer in the Cornbrash, but despite several attempts at increasing the oil rate it never produced oil at the rates seen at the Kimmeridge 1 well.

The Kimmeridge 4 well was drilled at a surface location on the clifftop around 1 kilometre (3,281 feet) almost due west of the Kimmeridge 1 well. However, mechanical problems with the drilling rig curtailed drilling after only four days and the well was abandoned and the well site restored.

The Kimmeridge 2 well was drilled some 700 metres (2,300 feet) to the east of the Kimmeridge 1 well during July to September 1960. The well entered the Cornbrash Limestone Formation at 583 metres (1,913 feet). On test it produced oil from the Oxford Clay and the Cornbrash Limestone at around 4 bpd and, somewhat strangely, even less after cleaning up. Clearly, this well was never going to be a producer and so BP retained it, for a time, as an observation well to monitor pressures.

In January 1980 BP started drilling the Kimmeridge 5 well, at a surface location just 59 metres (194 feet) from the Kimmeridge 1 well, in order to appraise the oil producing potential of the deeper Sherwood Sands, which by this time were known to be oil productive at the nearby Wytch Farm oilfield. The Kimmeridge 5 well was drilled as a highly deviated well. The well

trajectory first went north and then at a vertical depth of around 1,135 metres (3,723 feet) subsea it turned east and then south to reach a total vertical depth of 2,738 metres (8,985 feet) subsea, deep under Kimmeridge Bay. However, despite encountering the Sherwood Sands deeper than expected only slight oil shows were found and the quality of the sands proved much poorer than at Wytch Farm. By May 1980, BP had plugged and abandoned the well and restored the site. This illustrates the uncertainty of oil exploration. A specific rock formation that is oil bearing at one location can be quite devoid of oil at another.

The purpose of the Kimmeridge 2 and 3 wells was to appraise the extent of the oilfield. However, since none of these wells had discovered oil in sufficient producible quantities it could be concluded that the Kimmeridge 1 well was in direct communication with a relatively small volume of oil in place. This reasoning presented BP with something of an enigma. By the turn of the millennium the single Kimmeridge 1 well had produced, in forty years, over 3.2 million barrels of oil at sustainable rates that had peaked at 500 bpd and then declined steeply at first and then more slowly at less than 5 per cent per annum. The oil production data from the Kimmeridge 1 well and the lack of oil at other nearby wells seems to indicate a larger oil volume than originally thought is in communication with this well. This poses an obvious question. Where is this additional reservoir of oil feeding the Kimmeridge 1 well?

Over the years a number of feasible explanations have been put forward to explain this apparent contradiction. Theories have ranged from large offshore oil reservoirs to oil migration from underlying reservoirs and have been summed up in reports to the Geological Society. It has been generally agreed that the bulk of the Kimmeridge oil production comes from and through the natural fissures in the Cornbrash Limestone. The problem here is the volume of the fissures in direct contact with the Kimmeridge 1 well is not big enough to account for the volume of oil produced to date. Therefore, it has been postulated that these fissures could extend into a more extensive fissured system outside the Cornbrash reservoir. Such a mechanism could tap into oil contained within a larger onshore or offshore naturally fractured and fissured geological formation, not directly encountered by any of the Kimmeridge wells drilled to date. However, the exact location of such a formation is still unknown.

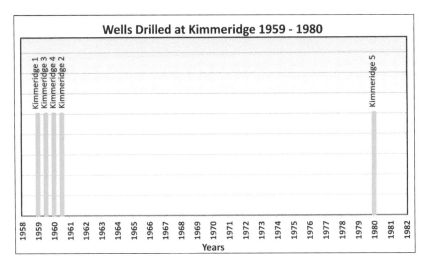

Timeline of wells drilled by BP on the clifftop at Kimmeridge since 1959. (Author, contains information from the Oil and Gas Authority (OGA))

7
Wareham Oilfield, 1964–2019

The Wareham oilfield was discovered by BP Petroleum Development Limited (BP) as operator in October 1964 with a conventional vertical well drilled under licence B183, later to become licence number PL089. This well is reported as having produced oil on test at 20 barrels per day (bpd) from the limestones of the middle Jurassic Great Oolite Series and the upper part of the Bridport Sandstone. Today, the oilfield is operated from two sites called Wareham C and Wareham D. Both sites lie just outside the town of Wareham and just off the A352 Wareham to Dorchester road, although neither can be seen from the roadside except when a drilling rig is operating. The oil is contained within an elongated Bridport Sandstone structure lying roughly west to east and with its lowest extent governed by an oil water contact at depth below 934 metres (3,064 feet).

A second vertical well, Wareham 2, was drilled by BP as operator during January and February 1965. This well, like its predecessor, had oil shows in the limestone reservoirs of the Great Oolite, the Cornbrash and Forest Marble, at vertical depths of around 666 metres (2,185 feet) subsea. There were also oil shows in the Inferior Oolite just above the Bridport Sands at true vertical depths of 865 metres (2,838 feet) subsea. According to a book by Huxley, the two wells were not produced until 1970 and then at oil rates of around 100 bpd, with increasing water cut.

No further drilling activity took place at Wareham for at least another twelve years. The next well to be drilled was Wareham C1 (3) during October 1977. This well was drilled by British Gas (BG) not BP. The well was drilled from the Wareham C site as a conventional deviated well, which headed north for around 7 kilometres. It encountered the oil-bearing Bridport Sandstone reservoir at a vertical depth of 829 metres (2,721 feet) subsea. At this location the Bridport Formation was logged with a gross vertical thickness of some 90 metres (292 feet), although it has to be said that oil was not found throughout this thickness. A further period of nearly three years elapsed before BG, still operator of the licence, drilled four conventional wells during September to December 1980 – two at the Wareham C site and two at Wareham D.

The first of these wells was Wareham W1 (D4), which started drilling on 13 September 1980 and was drilled as a deviated well, finally being completed towards the end of September. It discovered oil in the upper part of the Bridport Sandstone reservoir at a true vertical depth of 816 metres (2,677 feet) subsea. The well was drilled deeper to a total

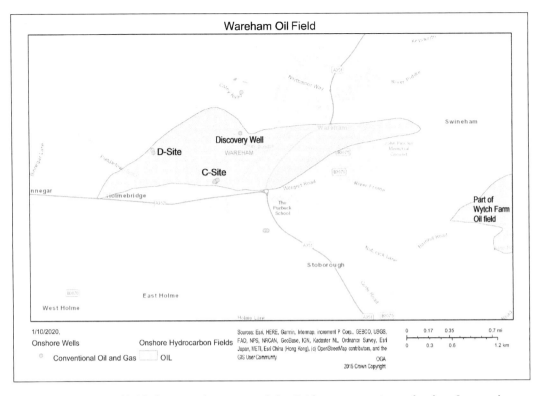

Map of Wareham oilfield showing the extent of the Bridport reservoir, at depths of around 900 metres (2,953 feet) and surface well site locations C and D. (Author. Sources: Esri, HERE, Garmin, Intermap, increment P Corp., GEBCO, USGS, FAC, NPS, NRCAN, GeoBase, IGN, Kadaster NL, Ordnance Survey, Esri Japan, METI, Esri China (Hong Kong), © OpenStreetMap contributors, and the GIS user community, Oil and Gas Authority OGA 2015 Crown Copyright)

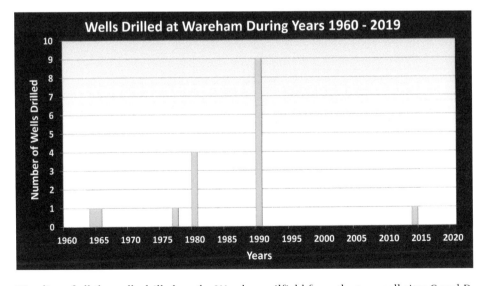

Timeline of all the wells drilled on the Wareham oilfield from the two well sites C and D. (Author, contains information from Oil and Gas Authority (OGA))

depth of 952 metres (3,123feet), but found no further oil. The next well to be drilled was Wareham W2 (D5), which started drilling on 23 October 1980 and drilled as a vertical exploration well to a total vertical depth of 1,056 metres (3,464 feet) subsea and completed on 19 November 1980. It discovered oil at the top of the Bridport Sandstone at a vertical depth of 843 metres (2,766 feet).

The next two wells were drilled at the C site. The first of these was Wareham C2 (C6), which started drilling 26 November 1980 and drilled as a vertical development well. Despite reaching a total vertical depth of 1,149 metres (3,770 feet) subsea, it failed to encounter the Bridport Sandstone and failed to find any oil shows. As a result the well was deepened and reclassified as side track well Wareham C6Z. This well was deviated to the west and reached a total vertical depth of 1,794 metres (5,886 feet) subsea. On its way, it passed through the Bridport Sandstone and then encountered the Sherwood Sandstone Group at a vertical depth of 1,573 metres (5,161 feet), which was known at this time to be an oil-bearing reservoir at the nearby Wytch Farm oilfield. However, no oil was discovered either in the Bridport or the Sherwood sandstones and the well was abandoned on 29 December 1980. This failure to find oil illustrates the risky nature of oilfield development even when an oil-bearing reservoir, the Bridport Sandstone in this case, had been established at other locations in this field and at the Wytch Farm oilfield.

The drilling timeline of wells at the Wareham oilfield shows that another ten years elapsed before any further drilling took place. Then in 1990 there was a drilling frenzy with wells going down at the rate of around one every two weeks. By this time, British Gas (BG) had been forced to give up all its oil interests both onshore and offshore prior to privatisation and as a result BP had become operator of the Wareham oilfield. Obviously, at this time BP were keen to further appraise and bring the field into production as soon as possible. In all, nine conventional development wells, all deviated, were drilled during the period from March to end of July 1990, six from the C site and three from the D site.

The first of this clutch of wells was Wareham C3, which started drilling on 1 March 1990 and completed just seventeen days later on 18 March. This well was deviated out to the north-east and encountered the Bridport oil reservoir at a vertical depth of 829 metres (2,720 feet) subsea. The remaining five wells were named in succession Wareham C4 to Wareham C8. The last of these was completed on 31 May 1990. The C4 and C7 wells were drilled as water injection wells. The three wells drilled at the D site were named in succession Wareham W3 to Wareham W5. The last of these was finally completed 28 July 1990. The W3 and W4 wells were designated water injection wells.

It appears that by the end of 1990 a development plan was finally in place for the Wareham oilfield. This conventional field development was based on the eight oil production wells and four water injection wells already drilled by BG and BP. The plan called for fluids from all the Wareham production wells to be sent by pipeline to the gathering station at Wytch Farm oilfield, where gas and water would be separated from the oil. The resulting stabilised Wareham oil added to the oil from the Wytch Farm wells. The plan itself received consent from the UK Department of Energy, who at the time regulated all onshore and offshore oil and gas field developments on the UK Continental Shelf. Since the plan involved water injection into a conventional sandstone oil reservoir BP would have needed to show that the planned water injection pressures did not exceed the natural fracture pressures of the rock itself. Water would simply be used to maintain pressure in the reservoir and to sweep oil towards the production wells. This was and still is a standard

An aerial view of well site D, Wareham oilfield. It contains the wellheads of three oil production wells fitted with beam pumps and two water injection wells. The wells drilled from here fan out into the Bridport reservoir 900 metres below. (Imagery © 2019 Google, Imagery © 2019 CNES/Airbus, Getmapping plc, Infoterra Ltd & Bluesky, Maxar Technologies, Map data © 2019)

reservoir engineering practice long used throughout the world to develop oil reservoirs. It is sometimes called water flooding. The use of water injection in this way should not be confused with the technique of hydraulic fracturing, 'fracking', which is used to extract oil and gas from reservoirs consisting of shale rocks.

With all the development wells and processing facilities in place and wells connected to surface beam pumps 'nodding donkeys', oil production started in earnest in March 1991. The daily oil rate averaged over the ten months of the first year of oil production was 1,877 bpd. BP started to inject water at the four injection wells in June 1991. Prior to 1991 BP produced some oil from the early Wareham wells during short duration well tests.

Photograph looking through the gate of the Wareham D well site, showing two beam pumps pumping oil through the wellheads of two production wells. (© Copyright John Lamper and licensed for reuse under CC-by-SA 2.0)

Since the oil volumes produced were very small these early production figures are not shown in the timeline. For the first two years after 1991 the oil rate peaked at nearly 2,000 bpd, but after 1993 declined quite quickly falling to less than 500 bpd by 1998 as more and more water broke through into the production wells. Most of this produced water came from injected water in an attempt to maintain reservoir pressure and sweep oil to the production wells. In an effort to slow the rising water cut, BP stopped water injection at the C site in June 1996. In this they were successful for a time, as the rise in the water cut slowed after 1998. However, water injection was maintained at the W3 and W4 injection wells. After around 2005 the trend in the water cut continued to increase so the oil production fell into what is often called a 'production tail' during which oil is sustainably produced albeit at high water cuts. This production behaviour is typical of oilfields undergoing a water flood and is a sign that the water flood is behaving as it should.

In 2011, BP sold the Wareham oilfield as part of a package of Dorset oilfields to the Anglo-French oil company Perenco UK Limited. From this date Perenco has operated the field under the existing licence PL089. As part of its continuing development strategy of drilling infill wells, Perenco drilled a new well, Wareham C9, in November 2015, which came on stream in December. By the end of 2019 the cumulative volume of oil produced from the Wareham oilfield had reached 4.3 million barrels.

The future of the Wareham oilfield forms part of Perenco's long-term development strategy for the Dorset oilfields it operates. After a Public Consultation Event at Furzebrook Village Hall in May 2012 these plans were outlined in a planning document to Dorset County Council. In this document, Perenco envisaged one additional production well, now drilled, and continuation of oil production to the year 2030 at site C. At site D end of productive life is predicted by Perenco to be 2020. After these dates wells and surface equipment will be decommissioned and both sites (C and D) restored according to environmental best practices of the day.

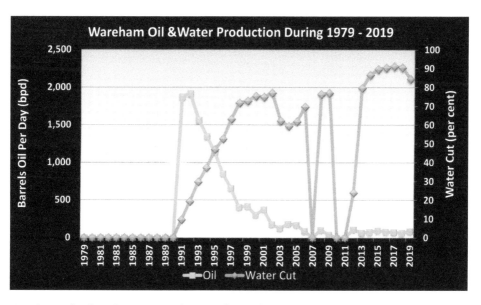

Timeline of oil and water production from the Wareham oilfield over a period of thirty years. (Author, contains information from Oil and Gas Authority (OGA))

<center>8</center>

Wytch Farm Oilfield, 1973–2019

The Wytch Farm oilfield in Dorset is the largest onshore oilfield in Britain and Western Europe and since its discovery has totally dominated the British onshore oil scene in terms of volumes of oil produced and the number of wells drilled. In addition, a number of world records have been achieved in terms of the complexity of wells drilled. Yet, despite all of these superlatives, the presence of the field's surface facilities is largely hidden from view, even from an elevated viewpoint. The Wytch Farm oilfield has sometimes been referred to as the 'hidden' oilfield. There is nothing visible to give a clue to the oilfield's whereabouts. Yet, hidden by trees there are ten well sites including those on Furzey Island and Goathorn Peninsular, one pumping station and a large gathering station together with all the interconnecting flowlines. Despite

Photograph looking north from an elevated viewpoint overlooking Godlingstone Heath from the Corfe to Studland road (B3351). Lying below, completely screened by trees, are the onshore well sites, flowlines and processing facilities of the Wytch Farm oilfield, from Arne (G site) to eastern end of Furzey Island (L site). (Author)

Arne — Wytch Farm Main Site — Round Island — Godlingston Heath — Poole — Furzey Island

its invisibility, Wytch Farm oilfield has its own postcode, BH20 5AR, and a signpost at the roundabout into the village of Corfe.

The size and complexity of the oilfield at Wytch Farm deserves its own publication to describe the history of its development. However, because this book covers the history of other Dorset oilfields the development of Wytch Farm has been summarised by dividing

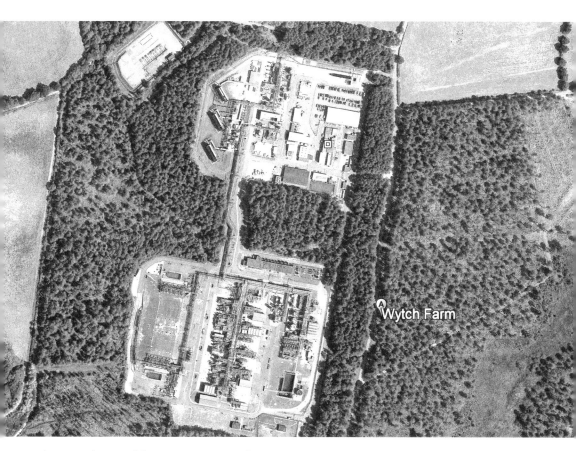

An aerial view of the main site at Wytch Farm oilfield. It houses two well sites, B1 and B2, and is the gathering station for oil from all other well sites, including Wareham and Kimmeridge. (Google Earth © 2020 Google, Image © 2020 TerraMetrics, Data: SIO, NOAA, US Navy, NGA, GEBCO)

This is the only ground level, publically accessible sign of the existence of the Wytch Farm oilfield, Britain's and Western Europe's largest onshore producing oilfield. (Author)

Wytch Farm Oilfield Development Phases

Dates	Development Stage	Key Events
1979 - 87	Phase 1	• Oil Production starts from Bridport reservoir • Oil is produced from conventional development wells fitted with 'nodding donkey' pumps at five sites • Water Injection starts fourth quarter 1980 • BP takes over operatorship from British gas Corporation following BGC privatisation • Oil & LPG to loading railhead at Furzebrook for onward journey to Hamble Terminal
1988 - 1993	Phase 2	• Use of high angle wells with ESPs to produce oil from deeper Sherwood reservoir lying onshore under Bridport reservoir • Oil production from Bridport & Sherwood reservoirs, first oil from Frome reservoir • BP builds oil pipeline to Hamble terminal & gas pipeline to Sopley during 1988 • Monthly average oil rate increases to over 71,000 bpd
1994 - 2001	Phase 3	• Use of ERD to reach offshore Sherwood reservoir with substantial oil volumes • World record for drilling longest step out well at 10 km (6.2 miles) under Poole Bay • Queen's Award for Environmental Achievement 1995 • Average oil rate peaks at 108,000 bpd for December 1996 • By 2001 78 per cent of all liquid volumes lifted to surface consist of water
2002 - 2008	Phase 4	• Use of multilateral wells to further develop Sherwood reservoir • Start of infill drilling • BP decommissions Furzebrook railhead
2009 - 2019	Phase 5	• Use of infill wells to maintain oil production • Water injected to achieve voidage replacement • Perenco takes over operatorship from BP in 2011. Additional infill wells to increase oil rate • Waterflood management is used to sustain oil production at high watercuts • Licence approvals extended to 2037

bpd – barrels per day, ESP – electrical submersible pump, ERD – extended reach drilling

Photograph of a reference card showing the development phases of the Wytch Farm oilfield. (Author)

it into five development phases. Each phase covers a number of years and the key events happening during those years are set out in the text. In doing this, the demarcation of one phase and the next has necessarily been somewhat subjective. A summary of the phases of development at Wytch Farm oilfield has been tabulated on a card for reference.

Discovery and Phase 1 of Development (1973–87)

The discovery well, Wytch Farm X1(1), was drilled by British Gas Corporation (BGC) as operator of licence PL089. It was drilled as a vertical exploration well during the first half of December 1973. On test the well flowed oil, water and gas to surface from the Bridport Sand Formation at a true vertical depth of around 883 metres (2,897 feet) subsea. The discovery well was followed by three appraisal wells: two vertical wells, A1(2), B1(3) and a deviated well

D1(4), all drilled during the period January to April 1975. Each of these wells encountered the Bridport Sands and flowed oil and water to the surface on test. During November 1975, a second exploration well was drilled on the Arne Peninsular and unsurprisingly named Arne (G1). From the test results of these wells, BGC realised they had a significant oil-bearing reservoir in the Bridport Sand Formation and as a result drilled eighteen development wells during the years 1978 to 1981. Clusters of wells were drilled as deviated wells from single surface sites, all onshore. In all, there were five well sites at this time, labelled G1, X1, A1, B1 and D1. The wells were all conventional production wells, pumped using 'nodding donkey' beam pumps at steady oil rates of typically 300 to 500 barrels per day (bpd) per well. Three of these wells came on stream in March 1979 at a combined oil rate of nearly 900 bpd with little water. This marked the beginning of oil production from the Wytch Farm oilfield.

This initial phase of development of Wytch Farm was characterised by production of oil predominately from the Bridport reservoir, although some oil production came from wells drilled into the deeper Sherwood Sandstone reservoir. These traditional onshore wells were pumped at the surface using beam pumps, the ubiquitous 'nodding donkeys', at modest oil rates typically at hundreds of barrels per day rather than thousands. Towards the end of this initial development phase only a couple of additional appraisal wells had been drilled and the number of producing wells had remained the same as earlier. However, at year end 1987 the average oil rate for the year had increased to just over 6,000 bpd with a water cut of just below 15 per cent.

Since discovering the Bridport oil reservoir at Wytch Farm, British Gas had long realised that to turn it into a viable producing oilfield they would need to solve the problem of transporting the oil from the site to a suitable refinery. At the time they predicted that

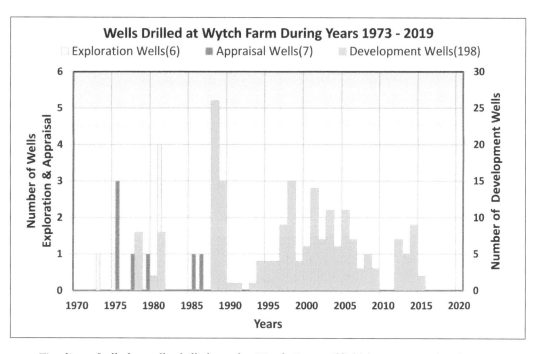

Timeline of all the wells drilled on the Wytch Farm oilfield by category. (Author, contains information from the Oil and Gas Authority (OGA))

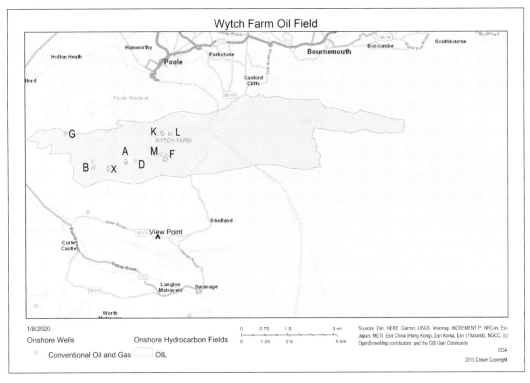

A map of Wytch Farm oilfield showing extent at deepest level, 1,625 metres, and onshore well site locations. Site B consists of two well sites, B1 and B2, and the gathering station and main site. (Author's well site and viewpoint annotations, contains information from the Oil and Gas Authority OGA 2015 Crown Copyright)

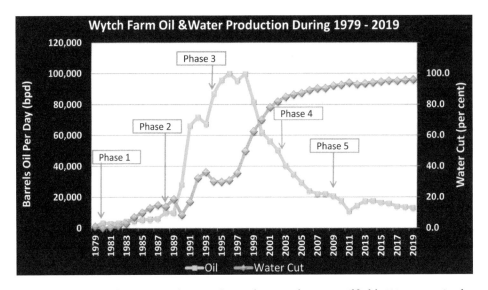

Timeline of oil and water production from the Wytch Farm oilfield. Water cut is the percentage of water in the total fluids produced. (Author, contains information from the Oil and Gas Authority (OGA))

A Class 66 diesel locomotive hauling a freight train carrying Liquefied Petroleum Gas (LPG) from Wytch Farm oilfield, most likely on the Furzebrook to Wareham single branch line. (Richard Brown/ Alamy Stock Photo)

oil production rates could reach 10,000 bpd or more. At such daily oil rates the option of road transport would have meant forty to fifty full road tanker movements per day. This was thought unacceptable from a road traffic point of view especially if oil production increased substantially. It was thought a marine tanker loading terminal on the fringes of Poole Harbour would be unacceptable on environmental grounds. At the daily oil rates envisaged at the time this left one option – rail transport. Fortunately, a standard gauge branch line, which had been used to transport clay from the local pits, existed between Furzebrook and the Swanage to Wareham railway line where it joined the main rail network. A railhead was built at Furzebrook, connected by pipeline to the gathering station at Wytch Farm, to load rail tankers with oil and liquefied petroleum gas (LPG).

It was about this time that the Conservative government of the day, under Prime Minister Thatcher, passed the Gas Act (1986), which led to the privatisation of the British Gas Corporation (BGC) and in the same year it became British Gas plc and was quoted on the London Stock Market. A rather bizarre consequence of this piece of legislation was that prior to privatisation BGC had to relinquish all of its UK oil assets. One can imagine the fury felt within BGC on learning of this requirement. This meant that BGC had to give up its operatorship of the Wytch Farm oilfield. The operatorship, under licence PL089, passed to British Petroleum (BP) during the latter part of 1985 and they marked the occasion by starting an appraisal well on 4 January 1986. A new development phase under the stewardship of BP was about to start.

Phase 2 of Development (1988–93)

Now, as operator of the Wytch Farm oilfield, BP launched a vigorous program of development. Their drilling program for the two years 1988/89 saw forty-one wells going down into the deeper Sherwood oil reservoir and completed at depths of generally greater than 1,585 metres (5,200 feet), nearly a mile below the ground surface. This period also saw the development of the oil-bearing Frome Clay Limestone reservoir that lies above and isolated from the Bridport Sandstone reservoir.

BP took advantage of advances in drilling technology to get the Sherwood wells to enter the reservoir at high angles away from the vertical so as to contact more of the reservoir than a vertical well would. In addition, these high-angle wells were fitted with downhole pumps, known as Electrical Submersible Pumps (ESPs), which allowed the wells to be produced at high oil rates. The early production data from these wells, reported through the Petroleum Production Reporting System (PPRS) to the Department of Energy, now Oil and Gas Authority, showed oil rates per well of typically 3,000 to 5,000 bpd, with one or two wells producing as much as 20,000 bpd. At this time such rates were unheard of for onshore oil wells in the UK, but were more typical of wells in Middle East oilfields or those of the North Sea. The lifting characteristics of ESPs meant that the wells could also be produced at high water cuts when water inevitably broke through into them.

To cope with the increasing oil production from Wytch Farm, BP built a 16-inch-diameter oil pipeline from the oil gathering station at the main site at Wytch Heath to their Hamble loading terminal, across Southampton Water, Hampshire. This 90-kilometre (55.9-miles) pipeline was routed to avoid all major urban conurbations and was opened in 1988. This enabled the stabilised crude oil to be pumped to the terminal for onward shipment to refineries by BP tanker ship.

BP also built an 8-inch-diameter gas pipeline from the gathering station to join up with the National Gas Grid at Sopley in Hampshire. It is worth noting that all gas in the UK passes through National Grid's National Transmission System (NTS) on its way to consumers. The BP pipeline was introduced to carry away most of the associated gas separated from the oil and processed to comply with NTS gas specifications. At the same time BP started using some of the gas as fuel to generate electricity to power the ESPs. Any gas not sent to the NTS or used as fuel was converted to liquefied petroleum gas (LPG) and carried by road tanker to the railhead at Furzebrook where 'gas trains' were loaded with the LPG for onward transport. With this infrastructure now in place the Wytch Heath gathering station was set up as a processing hub for oil production from the Wareham and Kimmeridge oilfields. Today, oil from the Wareham oilfield enters the hub by pipeline and from Kimmeridge by road tanker.

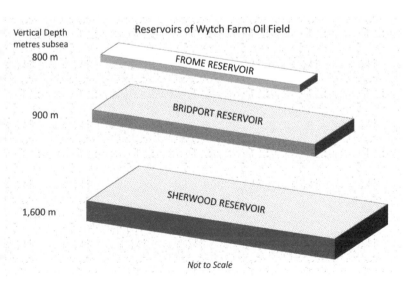

Schematic of the oil reservoirs of the Wytch Farm oilfield. The Sherwood Sandstone reservoir is the biggest and contributes most to oil production, followed by the Bridport Sandstone reservoir and the Frome Clay Limestone reservoir, which is the smallest and contributes the least to oil production. (Author)

Photograph of BP Hamble Oil Terminal, Southampton Water, Hampshire, UK. (Britpix/Alamy Stock Photo)

Here, any water in the oil and the associated gas can be separated out to provide stabilised crude oil for onward transmission through the pipeline to the Hamble oil terminal.

By the end of this phase of development in 1993 the average oil rate taken over the year had risen to just over 71,000 bpd and with an average water cut of around 35 per cent. By this time some forty wells were collectively producing oil from the three Wytch Farm reservoirs – the Frome, Bridport and Sherwood. In addition, twenty injection wells, dedicated to injecting water into the Bridport and Sherwood reservoirs, had been drilled by this stage. Collectively, these wells were injecting an average 106,000 barrels of water per day into the field as a whole to assist oil recovery and provide pressure support. Initially, water for injection came from abstracting sea water from tidal Poole Harbour. However, as the volume of produced water increased and subsequently reinjected the need for additional sea water diminished. The recycling of water in this way is a feature of water flooding oil reservoirs. For Wytch Farm reservoirs, this water injection was part of a carefully designed and controlled water flood to sweep oil towards the production wells and replace the voidage left by oil extraction.

Water injection into conventional sandstone and limestone oil reservoirs, such as those of the Wytch Farm oilfield, should not be confused with the practice of hydraulic fracturing, 'fracking'. Indeed, deliberately fracturing such oil reservoirs with water would physically damage them and would be counter-productive, since the aim of providing a uniform flood front would be destroyed. The dangers of injecting water into conventional oil reservoirs have been known to oil companies and regulators worldwide for at least fifty years. As a result, national regulators have strict guidelines in place to ensure operators of conventional water injection schemes do not exceed the natural fracture pressures of the rocks being subjected to water injection.

It was at the end of this phase of development that the estimate of ultimate oil recovery was revisited. At the time of discovery this estimate was put at 30 million barrels. The new estimate now stood at over ten times the previous estimate, 378 million barrels (hydrocarbons-technology website, 2016). Clearly, the Wytch Farm oilfield was turning out to be as big as some oilfields found under the North Sea.

Phase 3 of Development (1994–2001)

The third phase of development at Wytch Farm saw some of the most innovative and far-reaching developments ever carried out on an oilfield anywhere onshore Western Europe. At the end of 1993, BP realised that the Sherwood reservoir probably extended far beyond the onshore boundaries hitherto assumed and it was highly likely that considerable volumes of oil lay in Sherwood Sandstones offshore deep under Poole Bay. The problem facing BP at this time was how to reach this location. Several options were considered including fixed and floating production platforms offshore Bournemouth, artificial islands and subsea wellheads connected by undersea pipelines to existing facilities onshore. All of these options were dismissed because of the very sensitive nature of the marine and near onshore environments at Studland, Poole and Bournemouth. Not only did these support a number of designated environmentally sensitive sites and a considerable leisure industry, but a large amount of marine traffic used the narrow navigable channels in and out of Poole harbour. The same is true today. BP's solution was to exploit the technical advances in drilling oil wells that were taking place at this time.

In chapter two, it was explained how, when drilling, a well path can be made to deviate away from the vertical. In this way it is possible for a well to have a horizontal or near horizontal completed section, thereby increasing the contact with the reservoir, which, in turn, increases the oil rate. Extended Reach Drilling (ERD) is all about pushing these drilling techniques to the limit, thereby forcing the well path to be nearly horizontal over large horizontal distances from the surface drill site. During the period late 1993 to early 1994 BP set up two well sites, designated M and F, on Goathorn Peninsular just inside Poole Harbour, in order to drill extended reach wells. The target was the Sherwood reservoir located at depths of around 1,600 metres (5,249 feet) subsea and several kilometres offshore under Poole Bay.

In order to drill the very long wells to reach the offshore areas of the Sherwood reservoir, lying deep under Poole Bay, drilling contractors had to build new rigs or adapt existing ones. Either way, these ERD rigs broke with the traditional design by incorporating a motor drive below the travelling block at the top of the drill string. This effectively replaced the usual rotary table and kelly drive to rotate the drill string. In addition, the rig derricks were made taller so that 90-foot stands of pre-connected drill pipe could be stacked vertically. Each 90-foot section was made up of three 30-foot sections pre-connected at ground level and then lifted vertically into the stand. Together, these changes to rig design speeded up the drilling of extended reach wells since fewer drill pipe connections were needed while drilling long wells many kilometres from the drill site. Despite some automation these special drilling rigs still required worker intervention on the rig floor and aloft.

During the years 1994 to 2001, BP employed a number of drilling contractors to drill extended reach wells from onshore at the M and F sites to offshore with horizontal displacements up to 10 kilometres (6.2 miles). Some seventeen such wells were drilled. All of them terminated in the Sherwood reservoir at various vertical depths from 1,580 metres (5,184 feet) to over 1,700 metres (5,577 feet). Each well was completed with a horizontal producing section of around 1 kilometre (3,280 feet) in length and either a single or dual ESP to promote high oil rates. The peak oil rates from these wells usually occurred during the first year of production and varied from well to well. This variation in rates was quite wide from around 3,000 bpd to nearly 20,000 bpd with an average of around 12,000 bpd.

A schematic cross section of an Extended Reach Well at Wytch Farm oilfield. The longest well, M16Z, had a step out of nearly 11 kilometres (6.8 miles). (Author)

It is worth noting that at this time sustainable oil rates of this magnitude from a single onshore well had never been seen before in Britain. It was these wells that contributed to the monthly averaged peak rate of 108,000 bpd in December 1996. At the time this was the highest oil rate ever achieved for an onshore oilfield in Britain and Western Europe.

It was during this phase of development that a number of world drilling records were achieved. BP, in close partnership with one of its drilling contractors, planned a well to target a fault block in the Sherwood reservoir identified from seismic analysis. This was mapped at over 10 kilometre horizontal displacement from the M drill site on Goathorn Peninsular. Clearly, this target could only be reached using Extended Reach Drilling. The well, designated M16, started drilling on 1 March 1999. During its drilling M16 had to be side-tracked in order to reach the target producing zone and was given the designation M16Z. The side-tracked M16 turned out to be a world-record-breaking well, which, with a horizontal step out of 10.7 kilometres (6.65 miles), remained for many years the world's longest producing oil well. This broke a previous record of 10.1 kilometre step out for the M11 well. According to the PPRS data held at the Oil and Gas Authority (OGA), M16Z came on stream in July 1999 and by August had reached a very respectable average oil rate for the month of 13,881 bpd.

Not all the extended reach wells drilled during this development phase were destined to become long-term oil producers. Some of the oil production wells on the flanks of the reservoir were later turned into water injectors. An example of this was the M01 well, which came on stream in the autumn of 1994 and was turned around to water injection in March 1997. In the case of the M10 well, this was completed as a dual-purpose oil producer/water injector, producing oil from the Sherwood reservoir through a 1,000 metre (3,280 feet) horizontal section and injecting water further down-dip below the oil/water contact.

In 1995, BP Exploration Operating Company Ltd won the Queen's Award for Environmental Achievement at the Wytch Farm oilfield in acknowledgement of overcoming technical challenges leading to the environmentally beneficial manner in which the offshore section of the Sherwood reservoir was being developed.

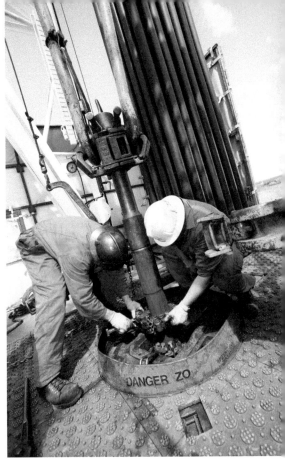

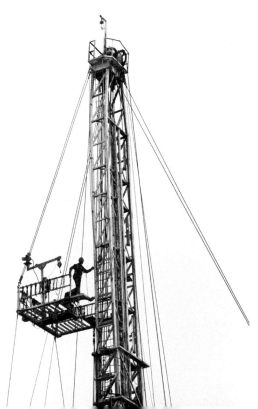

Above left: Photograph of a typical oil rig designed for extended reach drilling. It is fitted with a top drive assembly, yellow, and elevators, red, for lifting drill pipe. This speeds up pipe connections and allows use of 90-foot stands of pre-connected drill pipe. (Duncan Shaw/Alamy Stock Photo)

Above right: Photograph of rig workers on drill floor of top drive drilling rig getting ready to make a drill pipe connection. (Dan Bannister Tetra Images/Alamy Stock Photo)

Left: Photograph of a rig worker aloft on a drilling rig at Wytch Farm oilfield. (Mike Abrahams/Alamy Stock Photo)

Aerial photograph of Wytch Farm well site M. From this site, extended reach wells were drilled into the Sherwood oil reservoir deep under Poole Bay. The wells were fitted with ESPs. (Google Earth © 2020 Google, Image © 2020 TerraMetrics, Data: SIO, NOAA, US Navy, NGA, GEBCO)

At the end of the third phase of development, the oil rate had dropped to less than 60,000 bpd and the water cut had risen to around 78 per cent. In terms of active wells there were now forty-three oil producers and thirteen water injectors. The total cumulative oil produced to date was 353 million barrels, which happened to be close to the estimate of the ultimate recovery made at the end of 1993. Once again BP had to revise upward its estimate of ultimate recovery, since the field was still producing at nearly 60,000 bpd and was likely to continue producing for longer than originally thought. It was now thought that the ultimate oil recovery could reach 480 million barrels.

Phase 4 of Development (2002–08)

By the beginning of 2002 it was clear Wytch Farm oil production was in steep decline and so BP embarked on a programme of drilling infill wells to maintain oil rate. The number of development wells drilled ramped up quite considerably during the years 2002 to 2006. During this phase of development of Wytch Farm, BP took advantage of technical advances in drilling taking place at this time. Drilling techniques were being developed that allowed more than one horizontal section to be drilled from the same vertical mother well bore. Such wells were the multilateral wells described in chapter two.

An early example of a multilateral well came about as an earlier abandoned well M2 was side tracked twice to reach two targets. This was designated as a new well, M15, completed with two producing sections. Both laterals of this well went onto produce at combined peak

Photograph of a drilling rig at Wytch Farm oilfield on the edge of Poole Harbour at sunset. (Dom Greves/ Alamy Stock Photo)

oil rates of over 21,000 bpd. This is an example of using the new drilling techniques to make use of abandoned well bores to open up new oil-producing wells. In this case, the M15 well enabled production from two different sections of the Sherwood reservoir, effectively, functioning much like two wells but without doubling the construction expense. It was hailed by BP at the time as the world's first extended reach multilateral well.

During this phase of development from 2002 to end 2008 a total of fifty development wells were drilled. Many of these were multilateral oil production wells targeting two or more oil zones missed by previous wells. In this way the decline in the oil rate began to slow and eventually stabilise at around 22,000 bpd for the two years 2007 and 2008. However, the water cut continued to rise so that by the end of 2008 it had reached just over 90 per cent.

Phase 5 of Development (2009–19)

The key event of this phase of the development of Wytch Farm oilfield was the sale by BP of all its Dorset oil and gas assets to the Anglo-French oil company Perenco. This sale took place during 2011 and at the same time the operatorship of the licence PL089 passed from BP to Perenco. At first sight it might seem strange that BP should want to give up a field producing at

an oil rate of some 20,000 bpd, particularly as the oil price at the time was about $100 per barrel. Although never stated by BP, it is likely that the reason for the sale would have been about the economics of production, since the tax burden and overhead costs for a company the size of BP would have been bigger than for the smaller Perenco. The same is undoubtedly true today.

It is interesting to observe what happened to the drilling and oil rates during the years leading up to and immediately after the sale and transfer of operatorship. The timeline of wells drilled at Wytch Farm shows that no development wells were drilled during the years 2010 and 2011 and at the same time the average oil rate declined from around 17,500 bpd to around 10,700 bpd as shown by the production timeline. With the resumption of the development drilling of twelve new wells during the years 2012 and 2013, consisting of multilateral wells and single well bores, the oil rate returned to above 17,000 bpd, as shown in the production timeline. Clearly, oil production at this time was being sustained by the continuation of development drilling as well as water injection.

By the end of 2015, the total development well count at Wytch Farm oilfield had reached 198 including oil producers, water injectors and all manner of multilaterals and side tracks. It is a tribute to Perenco that in the four years from taking over the operatorship of Wytch Farm the company had drilled twenty-three additional development wells. At the same time the averaged oil rate had initially risen to 17,500 bpd at a water cut of just under 95 per cent. The continued production of oil at high water cuts is characteristic of mature oilfields subjected to water flood by water injection. Provided oil production remains economically viable, there is no reason why it should not continue up to water cuts of 98 per cent or more. Perenco must know this since they have committed to continuing oil production at Wytch Farm to the year 2037.

Since 2015, no new wells have been drilled at Wytch Farm. The oil production rate has slowly declined and during 2019 hovered around 13,000 bpd. The water cut has risen to around 96 per cent. By the end of 2019, 497 million barrels of oil have been produced from the Wytch Farm oilfield since production started in 1979, according to reported production figures held by the OGA.

Photograph of a top drive drilling rig on one of the drill sites on Furzey Island, part of Wytch Farm oilfield. (David Poole/Alamy Stock Photo)

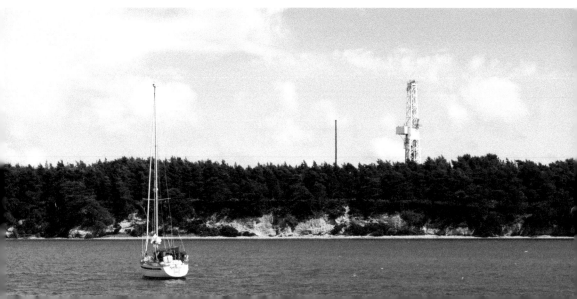

9

Waddock Cross Oilfield, 1982–2019

The Waddock Cross oilfield lies to the south of the A35 road between the county town of Dorchester, 10 kilometres (6.2 miles) to the west, and the town of Wareham, around 13 kilometres (8.1 miles) to the south-east.

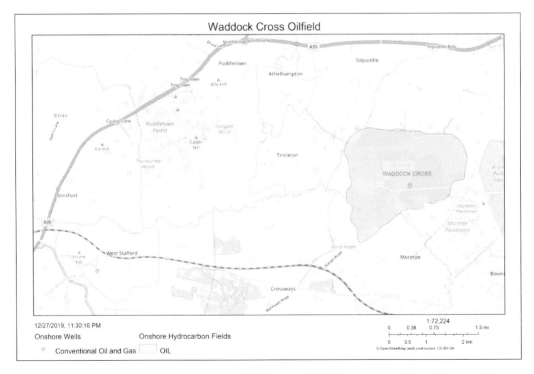

Map showing location and extent of the Waddock Cross oilfield. It consists of an oil reservoir in the Bridport Sand Formation at depths below 611 metres (2,005 feet) subsea (© OpenStreetMap and contributors, CC-BY-SA, Oil and Gas Authority OGA 2015 Crown Copyright)

The discovery well Waddock Cross 1 was drilled by Gas Council Exploration Ltd (GCE), as operator, in October 1982 under licence PL090. At the time GCE was a wholly owned subsidiary of British Gas (BG). The well was completed in December of the same year. This conventional, vertical well encountered the top of an oil-bearing Bridport Sand Formation at a vertical depth of 611 metres (2,005 feet) subsea. This formation gives rise to the oil-producing reservoirs at the Wytch Farm and Wareham oilfields. However, despite the Bridport reservoir in the Waddock Cross 1 well having a considerable gross thickness, it flowed on test at oil rates deemed by GCE to be uncommercial at the time. The well itself was drilled to a total vertical depth of 1,795.2 metres (5,890 feet) subsea, encountering the Sherwood Sandstone Group of rocks on the way. These rocks are oil bearing at the Wytch Farm oilfield but were found to contain only water at Waddock Cross. Nothing much happened at this site for the next twenty years.

The next reference to well site activity comes in 2003 when an appraisal well, Waddock Cross 2, started drilling on 13 December. This well was drilled by Egdon Resources plc, the first as operator in Dorset, under licence PL090, so presumably the licence had been relinquished by BG in the intervening period between the drilling of the two wells. Egdon Resources is an established operator of UK oil and gas onshore licences, with a listing on the Alternative Investment Market of the London Stock Exchange. The Waddock Cross 2 well was drilled as a conventional deviated well and encountered the top of the Bridport Sand Formation at a true vertical depth of 616 metres (2,021 feet) subsea. In January 2004, well tests were run that flowed oil at sustainable rates, but records show the oil was accompanied by copious volumes of water. However, the well was suspended as a potential oil producer.

During November and December 2005 a third well, Waddock Cross 3, was drilled by Egdon, again as operator, under licence PL090. This too was a deviated appraisal well,

A drilling rig at the Waddock Cross well site. (Copyright © First Oil Plc 2012)

An aerial view of the Waddock Cross well site taken in 2017. At this time production was suspended. (Google Earth)

which reached the top of the Bridport Sand Formation at a vertical depth of 617 metres (2,024 feet) subsea. The well was completed just below the top of the Bridport Sandstone with a horizontal section of length around 690 metres (2,263 feet) to potentially improve oil production. The design and drilling of this well followed closely that of the extended reach wells used at Wytch Farm oilfield, although much shorter in length.

After some postponements, Egdon reported at the end of 2011, 'a 6 month Extended Well Test (EWT) had commenced in August 2011'. The results of the EWT were reported in 2012, indicating that there was potential for commercial development and that a field development plan would be submitted. Egdon proposed an initial development phase that would access gross proven plus probable reserves of 300,000 barrels of oil out of a mapped oil volume in place of over 30 million barrels. Consequently, during 2013, approvals were sought and given by the UK Department of Energy and Climate Change (now OGA) and Dorset County Council for the development of the Waddock Cross oilfield to go ahead. The initial phase of the development called for a start-up oil rate of around 30 bpd from an existing well, Waddock Cross 2. This was to be followed by restoration of oil production from the Waddock Cross 3 well and then, at a later date, the drilling of a further two horizontal wells to increase and sustain oil production. Produced water would be reinjected on-site through a water disposal well. Produced oil would be taken away by road tanker.

After Egdon had installed larger production tubing and a more powerful pump at the Waddock Cross 2 well, the field was brought on stream at the end of 2013. The Petroleum Production Reporting System of the Oil and Gas Authority shows the first months' production in January 2014 at an average oil rate of 9 bpd and water rate of 450 bpd. The oil and water production timeline shows the average oil rate and water cut for each month

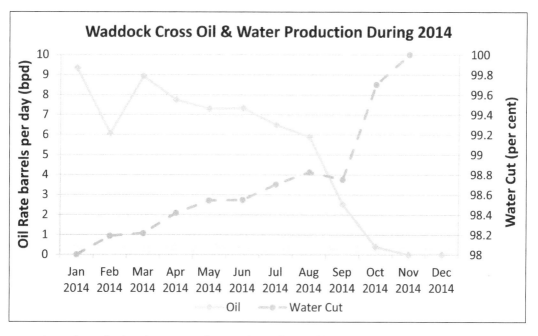

A timeline of oil and water production from the Waddock Cross oilfield over a period of one year. It was suspended at the end of 2014. Water cut is the percentage of water in the liquids produced. (Author, contains information from the Oil and Gas Authority (OGA))

during 2014. It shows oil production ceased after October 2014, having produced a total of 1,900 barrels of oil since start-up at water cuts in excess of 98 per cent.

As the oil price kept on falling during 2014–15 to below $40 per barrel, it was not surprising to find Egdon reporting in their Business Review of September 2015 that the Waddock Cross oilfield was 'shut-in due to lower oil production and fixed opex'. This meant that oil production was insufficient to pay for the operating expenditure (opex) of producing it. It is interesting to note that Egdon had previously referred to 'testing of high water-cut (>90%) Bridport Sandstone Oil discovery' in reference to Waddock Cross in their Preliminary Results Presentation for the year ended 31 July 2012. On that score the field had come up to expectation, since the water cut had never fallen below around 98 per cent since the field had started production.

10

Present Day Dorset Oil

It is now the year 2020 and the history of Dorset's oil industry is still evolving. Three of the Dorset oilfields operated by Perenco, Kimmeridge, Wareham and Wytch Farm, are still producing, although at much reduced oil rates from their heyday in the 1990s. Oil exploration has not ceased either, even after a fallow period of some seventeen years. It seems there is still some appetite for conventional oil exploration onshore and offshore Dorset with two companies willing to chance their luck. With the exodus of the onshore drilling rigs, the exploration well sites, other than those at the producing oilfields, have been restored to green field status. These have settled down, once more, to join the rural industries of farming and agriculture.

Continuing Production

At December 2019 the average oil rates from the Kimmeridge, Wareham and Wytch Farm oilfields were 74 bpd, 124 bpd and 13,100 bpd respectively. The cumulative volumes of oil produced at the end of 2019 from each of these oilfields amounted to at least 3.5 million barrels from Kimmeridge, 4.3 million barrels from Wareham and a massive 497 million barrels from Wytch Farm. Beyond 2020, Perenco has committed to produce oil from Kimmeridge to the end of productive life, which they estimate to be 2035 and the site restored by 2037. A similar commitment has been made to produce from the Wareham oilfield until 2030, with site restoration by 2032. Cessation of oil production from the Wytch Farm oilfield is much more complicated since it involves ten separate but linked well sites and the Purbeck to Hamble oil pipeline. It appears from Perenco's Environmental Statement of August 2012 that a phased cessation of oil production from Wytch Farm well sites will start from 2032, with the exception of the Arne G well site, which has an end of productive life estimated to be 2025, with site restoration by 2027. All other Wytch Farm well sites will be restored by end 2037 according to Perenco. Similarly, there is a commitment to decommission all infield flowlines and cables and the Purbeck to Hamble oil pipeline by the same date.

Further Exploration

The recent introduction in the UK of onshore exploration and development of unconventional hydrocarbon resources, such as oil shales, has had an impact on conventional oil exploration and development in Dorset, the subject of this book. The attention given to 'fracking' and unconventional oilfields has meant that exploration drilling and development of conventional oil resources is now receiving far greater public scrutiny than hitherto. Nevertheless, two oil companies have decided to explore for oil, offshore and onshore Dorset, using conventional drilling methods.

The first is Corallian Energy Ltd, a UK oil and gas exploration and appraisal company. In 2018 they acquired permissions to appraise existing hydrocarbon prospects in offshore licence block 98/11a. This licence block encompasses a sea area known as Poole Bay and is closed by the coastline from Studland Bay to the middle of Swanage Bay. This area had seen previous exploration drilling by British Gas and BP and a number of oil and gas prospects identified, which have remained undeveloped. One of these, the Colter prospect, which was discovered by British Gas in 1986, appealed to Corallian Energy for further appraisal. After being awarded the licence and permissions to drill they engaged an offshore drilling contractor, Ensco Limited, to use a jack-up drilling rig to drill a vertical appraisal well. A jack-up rig is a barge-like floating platform with a rotary drilling rig on board and with three legs that can be lowered to the seabed. It is towed to the offshore drilling location with the legs raised high above the platform. Once on location, the legs are lowered to the seabed, raising the platform above the water. In the case of the Colter prospect, which lies deep under the seabed in Poole Bay, the water depth is 18.5 metres (60.7 feet).

During the period from the beginning of February to early March 2019, Corallian employed the Ensco 72 jack-up rig to drill the conventional vertical appraisal well 98/11a-6

Photograph of a jack-up oil drilling rig, the Ensco 80 in this case, being towed in the Cromarty Firth. (Duncan Shaw/Alamy Stock Photo)

Photograph of the Ensco 72 jack-up drilling rig drilling the Colter oil prospect, lying some 1,800 metres deep under Poole Bay, for Corallian Energy during February–March 2019. (Author)

on the Colter prospect. The well reached a true vertical depth of around 1,840 metres (6,037 feet) subsea. Although it encountered oil and gas shows at the top of the Sherwood Sandstone Formation, the well seemed to show the Colter prospect was smaller than envisaged. Somewhat surprised by this result, Corallian sought and were granted permissions to drill a deviated borehole to a new subsurface location from the existing well. This new well, 98/11a-6Z, encountered oil and gas shows in the Cornbrash Limestone Formation, which is the oil-producing reservoir at the Kimmeridge oilfield. In addition, the well showed that another prospect, Colter South, was more extensive than originally thought. It is fair to say that any subsequent development of these Colter prospects would, inevitably, mean using extended reach drilling from onshore in much the same way this technique was used to help develop the Wytch Farm oilfield.

In 2016, South Western Energy Ltd, an oil exploration company based in Wales, were awarded an onshore petroleum exploration and development licence, PEDL327, covering three subareas in Dorset. The company subsequently applied for and were granted planning consent in 2020 by Dorset County Council to drill a conventional exploration well in one of the subareas defined by the licence. A mutually agreeable drill site was chosen, located to the north of the A35 road and around 2 kilometres (1.2 miles) north-east by east of Puddletown. The terms of the licence require a single conventional vertical well to be drilled so as to pass through the permeable rock formations of the Cornbrash Limestone and the Bridport Sandstone. Both of these rock formations are oil producing elsewhere in Dorset and so might be oil bearing at this location. The licence expects the well to terminate at 1,500 metres (4,921 feet) vertical depth subsea in the Lower Lias Group, whichever is the shallower.

Restoration

West Compton is a hamlet in rural West Dorset, around 7 miles east of the town of Bridport. It was here that the last conventional exploration well to date, West Compton 1, was drilled during the period 3 July to 18 August 2002. Unfortunately, no oil was found, despite the well passing through formations of the Cornbrash Limestone, the Bridport Sandstone and terminating in the Sherwood Sandstone, all oil-bearing rocks elsewhere in Dorset. Therefore, the well was plugged and safely abandoned and the well site and temporary trackways restored to green-field status.

It is interesting to compare aerial views of the West Compton well site and surrounding area taken in 2002 and 2017. The aerial view of 2002 shows the well site being prepared for the mobilisation of the drilling rig. Unfortunately, no aerial views have come to light with the drilling rig in situ. The view of 2017 shows the same location and surrounding area some fifteen years later. The other exploration well sites in Dorset, which are not part of a producing oilfield, have been restored in much the same way, leaving no signs of eighty years or so of oil exploration.

An aerial view of the site at West Compton being prepared for the oil rig to drill the West Compton 1 conventional exploration well in 2002. At the time the drilling rig and equipment had yet to be mobilised to the site. (Google Earth, © 2020 Infoterra Ltd and Bluesky)

An aerial view of the former oil exploration well site at West Compton taken in 2017. (Google Earth, © 2020 Infoterra Ltd and Bluesky)

Bibliography

Chapter 1

Arkell, William J., *The Geology of the Country Around Weymouth, Swanage, Corfe & Lulworth* (Memoirs of the Geological Survey of Great Britain, Institute of Geological Sciences, HMSO, 1947), https://www.bgs.ac.uk/

Oil and Gas Authority, OGA, https://www.ogauthority.co.uk/

Chapter 2

Mary Evans Picture Library, https://www.maryevans.com/

Chapter 3

Cope, John C. W., *Geology of the Dorset Coast: Geologists' Association Guide No. 22, 2nd Edition* (The Geologists' Association, 2016), https://geologistsassociation.org.uk/

Ensom, P., *Discover Dorset: Geology* (The Dovecote Press Limited, 1998)

Harvey, T., and Gray, J., *The Hydrocarbon Prospectivity of Britain's Onshore Basins* (Department of Energy & Climate Change, 2013, now OGA)

Underhill, J., and Stoneley, R., *Introduction to the Development, Evolution and Petroleum Geology of the Wessex Basin,* (Geological Society, London, Special Publications, 133, 1–18, 1998), http://sp.lyellcollection.org/

West, I., Geology of the Wessex Coast of Southern England, http://www.southampton.ac.uk/~imw/

Wilson, V., Welch, F. B. A., Robbie, J. A., and Green, G. W., *Geology of the Country Around Bridport and Yeovil* (London: The Institute of Geological Sciences, HMSO, 1958)

Chapter 4

British Newspaper Archive, https://www.britishnewspaperarchive.co.uk/

Denford, G. T., *Prehistoric and Romano-British Kimmeridge Shale: A Model for the Analysis of Artefacts* (PhD Thesis, University of London, 1995), https://archaeologydataservice.ac.uk/archives/view/denford_na_2000/overview.cfm

Mansel-Pleydell, J. C., *Kimmeridge Shale* (Proceedings of the Dorset Natural History and Antiquarian Field Club, 15, 172–183, 1894), http://archive.org/stream/proceedingsdorse15indors#page/172/mode/2up

The Dorset Shale Oil Industry, Museum of the Scottish Shale Oil Industry, http://www.scottishshale.co.uk/GazBeyond/BSEnglandShale/BSES_Dorset.html

Kilve Oil Works, Museum of the Scottish Shale Oil Industry, http://www.scottishshale.co.uk/GazBeyond/BSEnglandShale/BSES_Works/KilveOilWorks.html

Parkins, John, 'The Kimmeridge Shale Industry, Dorset' (*Bath Geological Society Journal*, 20, 14–19, 2001), https://bathgeolsoc.org.uk/journal/archive.html

Prudden, Hugh, *Somerset Geology: A Good Rocks Guide* (Somerset Geology Group, 2004), http://people.bath.ac.uk/exxbgs/Somerset_Good_Rock_Guide.pdf

Strahan, Aubrey, *Guide to the Geology of the Isle of Purbeck and Weymouth* (London: Memoirs of the Geological Survey, England & Wales, HMSO, 1898)

Strahan, Aubrey, *Guide to the Geological Model of the Isle of Purbeck* (London: Memoirs of the Geological Survey, England & Wales, HMSO, 1906)

Science and Society Picture Library, Science Museum, London https://www.scienceandsociety.co.uk/

Chapter 5

Pigott, Winifred, 'Oil at Kimmeridge' (*Dorset Year Book*, 61–63, 1959), http://www.societyofdorsetmen.co.uk/yearbook.html

Lees, George, and Cox, Percy, 'The Geological Basis of the Present Search for Oil in Great Britain by the D'Arcy Exploration Company Ltd' (*Quarterly Journal of the Geological Society*, 93, 156–194, March 1937), https://jgs.lyellcollection.org/content/93/1-4/156

Chapter 6

Gluyas, J., Evans, I. J., and Richards, D., 'The Kimmeridge Bay Oilfield, Dorset, UK Onshore' (Geological Society London Memoirs, 20 (1), 943–948, January 2003), https://www.researchgate.net/publication/240675816

Chapter 7

Huxley, John, *Britain's Onshore Oil Industry* (Macmillan Publishers Limited, 1983)

Chapter 8

Hydrocarbons Technology, Wytch Farm Oil Field (Hydrocarbons Technology Global Data, March 2017), https://www.hydrocarbons-technology.com/projects/wytch-farm-oil-field/

Lucas, C., Duffy, P., Randall, E., and Jalali, Y., *Near Wellbore Modelling to Assist Operation of an Intelligent Multilateral Well in the Sherwood Formation* (Society of Petroleum Engineers, Paper ID SPE-71828-MS, 2001)

MacGregor, Kenneth, and Reid, Paul, 'Using Sums not Simulators to Identify Infill Potential of a Mature Oilfield' (DEVEX Conference 2010 Day2 Room B, May 2010), http://www.devex-conference.org/programme_archives/2010-day2B.php

Perenco, UK, *Wytch Farm, Wareham and Kimmeridge Oilfields, Environmental Statement, Non-Technical Summary* (Perenco, August 2012)

Chapter 9

Egdon Resources plc, Presentations (2011–15), http://www.egdon-resources.com/media/2015-04-21-edr-interim-results-presentation_final-pdf/

Egdon Resources plc, Annual Reports (2011–15), http://www.egdon-resources.com/media/reports/

Chapter 10

Corallian Energy Limited, Wessex Basin Licences P1918, PED330, PEDL345, https://corallian.co.uk/projects

South Western Energy Limited, Puddletown Pilot Production Well: Scheme Overview for Puddletown Parish Council (Puddletown Area PC Minutes, Appendix A, 5 November 2019), http://www.puddletownareaparishcouncil.co.uk/

Acknowledgements

A book such as this one does not get written without the help of others, which I acknowledge here.

I would like to thank my good friend Faith Lamb who has been involved with this project from the start. In proofreading the text of this book she became particularly adept at removing commas where they didn't belong and adding them where they did. Thanks are also due to Gail Critchell for helping out with geological field trips along the Dorset coast. I should like to thank Connor Stait and his colleagues at Amberley Publishing for their help, encouragement and guidance in producing this book.

Images reproduced in this book have come from my own photographic and book collections and a variety of UK based sources such as photo and picture libraries, museums and national archives. The attribution, copyright and database right are given in the author's captions to each of these images.

I should like to thank the following people and their respective organisations for help in providing many of the images that are reproduced in this book: Eddie Bundy, Data and Copyright Executive at the British Newspaper Archive, for the high-resolution images of the 160-year-old newspaper articles shown in chapter four; Luci Gosling, Head of Sales and Research at Mary Evans Picture Library, for sourcing oil industry related images that appear in chapters two and five; Justin Hobson, Image Licensing Executive at the Science Museum, London, for the photograph of a model of James Young's patented oil shale retort shown in chapter four; Amy Muir, Collections and Interpretations Officer at the Museum of the Scottish Shale Oil Industry, for advise in sourcing the original newspaper articles shown in chapter four; and Nick Wright, Editor, Dorset Year Book, for permission to reproduce a photograph from the 1959 edition, shown in chapter five.

My thanks to Symon Porteous and his colleagues at Lovell Johns Ltd, a leading cartographic services company, for the map of Dorset's exploration oil wells shown in chapter five (https://www.lovelljohns.com/).

The text, maps and graphs in this book contain information provided by the Oil and Gas Authority (OGA) and are reproduced here according to the terms of the OGA open

user licence of June 2019 (https://www.ogauthority.co.uk/media/5850/oga-open-user-licence_210619v2.pdf).

Images of oilfield equipment from the Creative Commons Share Alike Licencing scheme have been reproduced in chapters six and seven of this book according to the licence terms granted to the UK (https://creativecommons.org/licenses/by-sa/2.0/uk/legalcode).

Aerial views of well sites have been obtained from images provided by Google Earth and are reproduced here in chapters seven, eight and nine of this book according to the terms specified (https://www.google.com/permissions/geoguidelines/).

I would like to acknowledge the UK based Alamy Photo Stock Library for providing some of the images appearing in chapters two, five, eight and ten of this book (https://www.alamy.com/).

Every attempt has been made to seek permission for copyright and database right material used in this book. However, if we have inadvertently used copyright and database right material without permission/acknowledgement we apologise and we will make the necessary correction at the earliest opportunity.